A YEAR
WITH THE
SAINTS

MARK WATER

Liguori
LIGUORI, MISSOURI

Copyright © 1997 Hunt & Thorpe

Text Copyright © 1997 Mark Water

Published by Liguori Publications
Liguori, Missouri

This edition published 1997 by special arrangement with Hunt & Thorpe,
New Alresford, Hampshire, United Kingdom

Library of Congress Cataloging-in-Publication Data

Water, Mark
 A year with the saints/Water, Mark – 1st U.S. ed.
 p. cm.
 ISBN 0–7648–0112–0
 1. Christian Saints – Biography. 2. Christian saints – Calendar.
 3. Devotional calendars. I. Title
 BX4655.2.B23 1997
 270'.092'2 – dc21
 [B] 96-53169

First U.S. Edition
01 00 99 98 97 5 4 3 2 1
Printed in Hong Kong

A YEAR
WITH THE
SAINTS

CONTENTS

INTRODUCTION

N THE NEW TESTAMENT the word "saint" meant "Christian." Nowadays we think of saints as people who lead particularly holy lives, or who dedicate their lives to caring for others in the service of Christ.

Desmond Doig, in his book Mother Teresa: Her People and Her Work, writes, "I was seated next to a Calcutta socialite who was discussing her latest charity. I asked her if she had heard of Mother Teresa. She paused, looked quizzically surprised, and said, 'Yes, I have, actually. She's something of a saint, isn't she?'"

In some hymn books W. W. How's famous hymn about saints has a quotation from Hebrews 12:1 at the top: "So great a cloud of witnesses." We may have little reason to think of ourselves as saints, but we can give thanks for those who undoubtedly were.

> For all the saints who from their labors rest,
> Who Thee by faith before the world confessed,
> Thy name, O Jesu, be for ever blessed.
> Hallelujah! Hallelujah!

W. W. HOW

JANUARY

ASIL THE GREAT,
*the founder of the ideal of monastic community life, discovered,
like many saints before and after him, that the closer he came to
God, the more aware he became of his own shortcomings and sin. Basil once
wrote: "Our nature is so vitiated, and has such a propensity to sin, that unless
it is renewed by the Holy Spirit, no man can do or will what is good of himself."*

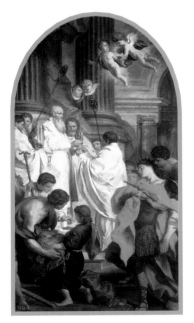

MASS OF ST. BASIL

✳ JANUARY ✳

SOLEMNITY OF MARY, MOTHER OF GOD

"*C*ommemorating *our most holy, most pure, most blessed and glorious Lady, Mary, ever Virgin and Mother of God, with all the saints, let us commend ourselves and one another and our whole life to Christ our God For to you, O Lord, belongs all glory, all honor and all worship, now and forever. Amen.*"

LITURGY OF ST. JOHN
CHRYSOSTOM

BASIL THE GREAT
(*C. 330–379*) BISHOP AND THEOLOGIAN

*A*S BISHOP of Caesarea, Basil spent his life preaching and writing to defend the Christian faith against heresy and persecution. When hauled before the emperor's court, Basil surprised the local prefect by his robust stand, saying, "*Perhaps you have never before had to deal with a proper bishop.*"

GENEVIEVE
(*c. 422–500*) PATRON SAINT OF PARIS

*A*T the age of seven, Geneviève dedicated her life to God, and at 15 she became a nun. When Paris was under siege from the Franks, Geneviève arranged for boatloads of food to be brought in for the starving people. When Attila II and the Huns advanced toward Paris, Geneviève rallied the people to prayer. Her prophecy that the city would be unharmed came true as Attila's army bypassed Paris.

In art Geneviève is usually depicted as a shepherdess holding a candle, which the devil is attempting to blow out while angels protect it.

✳ JANUARY ✳

ELIZABETH ANNE BAYLEY SETON
(1774–1821) FOUNDRESS

*B*ORN in New York, Elizabeth Seton was the first native-born U.S. citizen to be made a saint. She founded the Sisters of Charity of St. Joseph, the first American sisterhood, which cares for the children of the poor.

JOHN NEPOMUCENE NEUMANN
(1811–1860) BISHOP AND FOUNDER

NEUMANN, born in Bohemia, emigrated to America, where he worked as a pastor for 24 years, most of the time as a Redemptorist missionary. After he had become Bishop of Philadelphia, he founded the Third Order of St. Francis of Philadelphia, a congregation of religious women. He was canonized on June 19, 1977, by Pope Paul VI.

BALTHASAR, CASPAR, AND MELCHIOR
(1ST CENTURY) KINGS

IN the Christmas story, "Magi from the east came to Jerusalem" (Matthew 2:1). Tradition has it that they were three in number, for we know that three gifts were presented. Since the sixth century they have been thought of as kings, and since the eighth century they have had the names Balthasar, Caspar, and Melchior.

LUCIAN OF ANTIOCH
(DIED 312) MARTYR

LUCIAN, head of a theological school in Antioch, devoted his life to studying the Bible. He revised the Greek text of the Old Testament and the Gospels. After a nine-year imprisonment he was martyred in the persecution that took place in the reign of the Emperor Diocletian.

✳ JANUARY ✳

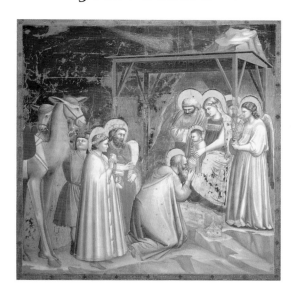

APOLLINARIS
THE APOLOGIST
(DIED C. 180) BISHOP

A POLLINARIS, Bishop of Hierapolis in Phrygia, became so well known and respected for his writing and teaching that an imperial edict was issued forbidding any Christian to be denounced because of his religion. His most famous writing, the *Apologia for the Christian Faith*, was dedicated to the Emperor Marcus Aurelius.

PETER OF SEBASTEA
(340–391) BISHOP

Y OUNGER brother of Basil the Great, Peter became abbot of a monastery in Armenia before being made Bishop of Sebastea. He is remembered for his efforts to alleviate the suffering of the starving people of Pontus and Cappadocia during a severe famine.

✳ JANUARY ✳

MARCIAN
(DIED C. 471) CHURCH LEADER

BORN in Constantinople, he became "Oikonomos," the second most important person in the Church hierarchy, in his native town. He built several churches, most notably the Anastasis, and is remembered for his care of the poor.

THEODOSIUS
THE CENOBIARCH
(423–529) ABBOT

THEODOSIUS was put in charge of a church on the road between Jerusalem and Bethlehem. Later he founded a monastery by the Dead Sea, where several hundred monks came to live under his rule. He was appointed head of all cenobites (monks living in monasteries) in Palestine. He also built three hospices for the mentally ill, elderly, and physically sick.

MARGARET BOURGEOYS
(1620–1700) TEACHER

MARGARET Bourgeoys, born at Troyes in Champagne, France, went to teach children in Montreal, Canada, in 1657. In 1676 she founded her Congregation of Notre Dame of Montreal, an enclosed community of women, in the teeth of bitter opposition. She was beatified in 1950.

HILARY
(315–368) BISHOP AND THEOLOGIAN

*H*ILARY, Bishop of Poitiers, one of the most respected theologians of his day, was an outstanding teacher of the Christian faith. He grew up in a wealthy and cultured pagan home, and became a Christian as an adult through reading the Bible on his own.

✴ JANUARY ✴

FELIX OF NOLA
(DIED C. 260) CONFESSOR

FELIX'S quiet retirement at Nola, near Naples, was shattered when Emperor Decius persecuted all the Christians he could find. Felix went into hiding, and at one time rescued and nursed Maximus, the ailing, elderly Bishop of Nola. After Decius' persecutions, Felix lived quietly, sharing all he had with the poor.

REMIGIUS
(C. 437–530) EVANGELIST

REMIGIUS, also known as Remi, was born at Laon in France. He became renowned for his preaching, and was appointed Bishop of Rheims at the age of 22. He devoted more than 70 years of his life to evangelizing the Franks, and so became known as "the Apostle of the Franks." The most influential bishop in Gaul, he was greatly admired for his learning and holiness.

BERARD
(DIED 1220) MARTYR AND FRANCISCAN

FRANCIS of Assisi sent Berard, along with four other friars, Peter, Otto, Accursius, and Adjustus, to preach the Christian gospel to the Muslims. They were banished by the Moors at Seville but, undeterred, they traveled on to Morocco. There they refused to stop preaching, or to leave, so Sultan Abu Jacob beheaded them with his scimitar.

ANTONY OF EGYPT
(251–356) ABBOT

BORN at Coma in Upper Egypt, Antony gave away his inherited wealth and became a hermit. For 33 years he lived a life of prayer and solitude in a tomb in a cemetery, and later in a deserted old fort. He then organized all the ascetics who had come to live around the fort, giving them a common rule to live by. This was the first Christian monastery. Today, Antony is known as the father of all monks.

✳ JANUARY ✳

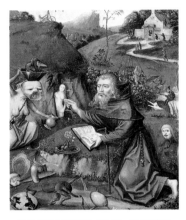

THE TEMPTATION OF ST. ANTHONY

ATHANASIUS
(C. 297–373) BISHOP AND THEOLGIAN

ATHANASIUS was one of the greatest theologians of the Christian Church. He has been called "Pillar of the Church," "Father of Orthodoxy" and "Champion of Christ's Divinity," as he set his face against the heretics of his day – the Arians. One of the three major Christian Creeds, the Athanasian Creed, while not written by Athanasius himself, was based on his writings.

HENRY OF UPPSALA
(DIED C. 1156)
BISHOP, MARTYR, AND
PATRON SAINT OF FINLAND

HENRY, an Englishman, accompanied Nicholas Breakspear (later Pope Adrian IV) to Norway and to Sweden, where he was made Bishop of Uppsala. While working as a missionary in Finland, he was murdered by a Finn named Lalli, whom he had excommunicated.

JANUARY 20

FABIAN
(DIED 250) POPE AND MARTYR

*F*ABIAN was elected Pope on January 10, 236, even though he was a layman, because a dove had landed on his head during the election process. During the fierce persecutions under Emperor Decius, Fabian was martyred.

JANUARY 21

AGNES
(DIED C. 304) MARTYR

*A*GNES came from a wealthy Roman family. As a young girl, she dedicated herself to God and decided never to marry. Although only 13, she was threatened with torture but this did not make her deny her Christian faith. She was sent to a brothel in Rome where she maintained her dedication to God. Returned to the Roman governor, she was beheaded. Agnes is patroness of chastity, and in art is represented by a lamb (the Latin word for lamb is *agnus*), the symbol of purity and innocence.

JANUARY 22

VINCENT THE DEACON
(DIED 304) MARTYR

*B*ORN at Huesca, in Spain, Vincent was arrested with Bishop Valerius of Saragossa, who had ordained him and encouraged him to preach. Vincent was tortured mercilessly, because he would neither offer sacrifices to the gods nor give up his sacred books. He died in prison on January 22, but not before he had converted his prison warden. Vincent, patron of vine-growers, is depicted as a deacon holding jugs and a book.

JANUARY 23

EMERENTIANA
(DIED 304) MARTYR

*E*MERENTIANA was a Christian in Rome. She was stoned to death while she knelt in prayer at the tomb of her foster sister, St. Agnes.

✳ JANUARY ✳

FRANCIS DE SALES
(1567–1662) BISHOP AND THEOLOGIAN

DESPITE the opposition of his family, Francis abandoned his prospects of a brilliant secular career for the religious life. He spent five years as a missionary in the Chablais in France where his love, humility, and outstanding wisdom won thousands to Catholicism. His *Introduction to the Devout Life* and *Treatise on the Love of God* remain classics.

CONVERSION OF PAUL
(1ST CENTURY)
APOSTLE, MISSIONARY, AND MARTYR

PAUL was a charismatic preacher in the early Church whose teaching still guides the Church today. Paul is often called upon for protec- tion against snakebite, because when he was bitten by a viper on the island of Malta he did not die, but shook the snake into the fire.

WILLIAM BOOTH
(1829–1912) FOUNDER

GENERAL Booth founded the Salvation Army and devoted his life to evangelism and social work among the poor in England. His motto was, "Go for souls, and go for the worst."

ANGELA MERICI
(c. 1470–1540) FOUNDRESS

ANGELA Merici, born at Desenzano in Lombardy, Italy, received many visions. In one vision she was told that she would found the Ursulines. This came true in 1535 when 28 women dedicated themselves to God's service, under the protection of St. Ursula, with Angela as their superior. The Ursulines dedicated themselves to the religious education of poor girls.

✳ JANUARY ✳

THOMAS AQUINAS
(1225–1274) THEOLOGIAN

BORN in Italy, Aquinas became a Dominican monk, against the wishes of his family. In Aquinas the Middle Ages reached its full flowering and Christianity received its most influential intellect. His *Summa Theologiae* is rated as the greatest exposition of theological thought ever written. He is patron of universities, colleges, and schools.

GILDAS
(500–c. 570)

GILDAS, known as "the Wise," was born in Scotland and became an ascetic at Llanilltud, in Wales. Gildas is known for his book *De Excidio Britanniae*, "Concerning the Ruin and Conquest of Britain," a hard-hitting attack on the poor moral state of Britain.

ALDEGUNDIS
(630–684) ABBESS

BORN in Hainaut in Belgium, Aldegundis lived as a hermit. From her cell she founded what became the Benedictine monastery of Mauberge, of which she became abbess.

JOHN BOSCO
(1815–1888) FOUNDER

JOHN Bosco, born at Becchi in Piedmont, Italy, spent his life caring for neglected boys. By 1856 he was housing 150 boys himself and a further 500 in oratories, with just 10 priests. His need for assistants in this work led him to found the Society of St. Francis de Sales (the Salesians). By the time of Bosco's death there were 64 Salesian foundations in Europe and the Americas.

FEBRUARY

NE OF THE THINGS we look to the saints for is help in worship and in our own prayer life. To worship God in truth is to recognize him for what he is and to recognize ourselves for what we are. To worship God in truth is to recognize in verity and at this moment and in spirit that God is what he is, that is to say infinitely perfect, infinitely to be adored, infinitely removed from evil and thus with every attribute divine.

> What person shall there be,
> however small the reason he may have,
> who will not use all his strength
> to render to this great God
> his reverence and his worship?

BROTHER LAWRENCE,
The Practice of the Presence of God

✳ FEBRUARY ✳

BRIGID OF KILDARE
(c. 450–c. 525) FOUNDRESS

BRIGID founded the first nunnery in Ireland, at Kildare, and became, with Patrick, patron of Ireland. In art, she sometimes has a cow near her since she is reputed to protect dairy workers.

CORNELIUS
(1ST CENTURY) CENTURION

*A*fter Peter's strange vision of unclean animals, Cornelius, a centurion in the Italian Regiment, sent for Peter to visit his home. Peter told him that, "Everyone who believes [in Jesus] receives forgiveness of sins… [then] the Holy Spirit came on all who heard the message."

ACTS 10:43–44

BLAISE
(DIED C. 316) BISHOP AND MARTYR

BLAISE became Bishop of Sebastea in Armenia while still a young man. Because Christians were persecuted he became a hermit. He is reputed to have had unusual powers of healing, which extended to wild animals as well as people. Blaise was martyred during Licinius' persecution.

✳ FEBRUARY ✳

FEBRUARY 4

JOSEPH OF LEONISSA
(1556–1612) MISSIONARY

*E*UFRANIO, born in Italy at Leonissa, took the name Joseph on becoming a Capuchin monk at 18. He was sent as a missionary to Turkey, where he worked among the Christian galley-slaves and was himself tortured and imprisoned.

FEBRUARY 5

AGATHA
(DATES UNKNOWN) MARTYR

*L*EGEND says that, as a result of refusing to marry Quintilian, a Roman prefect sent by Emperor Decius, Agatha had her breasts cut off and was rolled in red-hot coals until she died.

FEBRUARY 6

PAUL MIKI
(1562–1597) MARTYR

*B*ORN at Tounucumada in Japan, Miki became a Jesuit and was famed for his preaching. He was crucified during a persecution of Christians under the Taiko, Toyotomi Hideyoshi, who ruled Japan for the emperor.

FEBRUARY 7

MARTYRS OF JAPAN
(1597) MARTYRS

*T*WENTY-FIVE Catholics were martyred with Paul Miki. Among them were Joachim Sakakibara, a cook for the Franciscans at Osaka; Francis, a carpenter; and Gabriel, aged 19, the son of a Franciscan porter. In 1862 they were all canonized as the Martyrs of Japan.

✳ FEBRUARY ✳

JOHN OF MATHA
(1160–1213) FOUNDER

OHN had the idea of founding a religious order to ransom Christian prisoners from the Muslims. He founded the order of the Most Holy Trinity (the Trinitarians), which was approved by Innocent III, and which managed to redeem many captives.

APOLLONIA
(DIED 249) DEACONESS AND MARTYR

HIS elderly deaconess had her teeth brutally pulled out as part of the torture and martyrdom she underwent in Alexandria when she refused to deny her Christian faith. She was happy to be "faithful unto death" for Christ.

SCHOLASTICA
(DIED 543) ABBESS

CHOLASTICA was St. Benedict's sister, possibly his twin, and is regarded as the first Benedictine nun, since she founded and became abbess of a convent near Monte Cassino called Plombariola.

✴ FEBRUARY ✴

THE BLESSED VIRGIN MARY

THE Song of Mary, or Magnificat, has been a source of inspiration for Christians through the centuries. In it Mary worships God, saying that he is her Savior: "My soul glorifies the Lord and my spirit rejoices in God my Savior, for he has been mindful of the humble state of his servant... His mercy extends to those who fear him."

LUKE 1:46–48, 50

BROTHER LAWRENCE
(1611–1691) SPIRITUAL WRITER

BROTHER Lawrence was born Nicholas Herman, in Lorraine, France, and was discharged from the army as a teenager because of ill health. In his middle life he became a lay brother with the Discalced (Barefoot) Carmelites. In his monastery kitchen he discovered an overwhelming delight in God's presence. His book, *The Practice of the Presence of God*, is a classic of simple spirituality.

CATHERINE DEI RICCI
(1522–1590) VISIONARY

CATHERINE was born in Florence and became a nun at the Dominican convent at Pratro in Tuscany. For a period of 12 years she received each week, at the same time, remarkable visions, in which she relived our Lord's Passion, during a time of extended ecstasy.

FEBRUARY

CYRIL AND METHODIUS
(C. 825–869; C. 826–884)
THEOLOGIANS

THE brothers Cyril (a secular priest) and Methodius (a monk in a Greek monastery) evangelized Moravia. In the teeth of bitter opposition, Methodius translated nearly all the Bible into Slavonic. They are known as "the Apostles of the Slavs" and were proclaimed co-patrons of Europe in 1980.

SIGFRID
(DIED C. 1045) BISHOP

SIGFRID, although he was ordained in York, England, became a famous missionary bishop in Sweden. He made his center at Växjö, in southern Sweden, from where he successfully evangelized the districts of Småland and Västergötland.

ONESIMUS
(DIED C. 90) MARTYR

ONESIMUS, the runaway slave, was converted by the apostle Paul in Rome and became his spiritual son. He was the reason for Paul's letter to Philemon, which is the only surviving example of a letter of a personal nature written by Paul.

THEODULUS
(DIED 303) MARTYR

THEODULUS, noted for his wisdom, held a senior post in the household of the governor of Palestine, Firmilian. As an old man, Theodulus allowed his Christian profession to be publicly known when he visited St. Elias in prison. For this Firmilian had Theodulus crucified.

✳ FEBRUARY ✳

FLAVIAN
(DIED 449) MARTYR

A PRIEST at a church in Constantinople, until he became its patriarch, Flavian refused to send a gift to the emperor on his coronation. So Chrysaphius, chancellor to Emperor Theodosius III, had Flavian beaten. Flavian died from his injuries, three days later near Sardis in Libya.

BONIFACE OF LAUSANNE
(c. 1205–1260) BISHOP

BONIFACE became Bishop of Lausanne in 1230, after he had exposed the corruption of the clergy. Emperor Frederick II's soldiers then attacked and wounded him and forced him to resign.

SADOTH
(DIED C. 342) BISHOP AND MARTYR

SADOTH succeeded a martyr bishop, Simeon Barsabae of Seleucia-Ctesiphon, in Persia, only to be tortured and beheaded himself within a year.

SEVERIAN
(DIED 453) BISHOP AND MARTYR

SEVERIAN, the Bishop of Scythopolis in Galilee, who loyally supported the traditional Christian faith, was killed when Jerusalem was taken and its Christians murdered by Emperor Theodosius II, who had been angered by the General Council of Chalcedon's criticisms of him.

✳ FEBRUARY ✳

MARGARET OF CORTONA
(DIED 1297) NUN

A FARMER'S daughter from Laviano in Tuscany, Margaret went to the church of Cortona to confess that she had been a nobleman's mistress for nine years. Then she placed herself under the care and direction of the Franciscan friars. Later she founded a convent and hospital that cared for nuns.

POLYCARP
(C. 69–C. 155) BISHOP AND MARTYR

POLYCARP was converted by John the Evangelist. We still have an authentic record of how Polycarp, as Bishop of Smyrna, was burned to death. During his trial he refused to recant, saying, "Eighty-six years have I served Jesus and he has done me no wrong. How can I blaspheme my king who saved me?"

MONTANUS, LUCIUS, AND COMPANIONS
(DIED 350) MARTYRS

C HRISTIANS were blamed for a riot in Carthage in 259. Eight followers of St. Cyprian, including Montanus and Lucius, were arrested. They were all tortured and beheaded.

WALBURGA
(DIED C. 779) ABBESS

W ALBURGA, born in Wessex, England, went to Germany to join St. Boniface's mission. From 761 she became head of the double monastery of Heidenheim. In German folklore, May 1 is known as *Walpurgisnacht*, the date that Walburga's bodily remains were transferred to Eichstätt.

✳ FEBRUARY ✳

NESTOR

(DIED 251) BISHOP AND MARTYR

ESTOR, Bishop of Magydos in Pamphylia, fell victim to Decius' persecution of the Christians. He endured martyrdom at Perga by means of a device that the Romans used, which they described as "the most painful way of executing anyone" – crucifixion.

GABRIEL POSSENTI

(1838–1862) CONFESSOR

ORN in Assisi, and christened Francis, he took the name of Gabriel of Our Lady of Sorrows when he joined the Jesuits at the age of 18, as a result of a vow in which he swore to become a Jesuit if he was healed of a severe illness. His holy and pious life, and especially his deprecation of himself, became so well known that he was canonized in 1902.

PROTERIUS

(DIED 457) MARTYR

ROTERIUS became the leader of the orthodox Christians in Alexandria, first as archpriest and then as patriarch. But on February 28, 457, he was stabbed to death by a group in Alexandria who opposed him.

JOHN CASSIAN

(c. 360–c. 430) FOUNDER

ohn Cassian spent 12 years in the Egyptian desert before he founded two monasteries near Marseilles, one for men and one for women. His books (*Institutes and Conferences*) greatly influenced Benedict. Cassian taught people to repeat a single verse in the Psalms to help their prayer life: "O Lord, come quickly to help me."

PSALM 70:1

The Saints as Patrons of People

ABANDONED CHILDREN
IVO; JEROME EMILIANI

ACADEMICS
THOMAS AQUINAS

ACCOUNTANTS
MATTHEW

ACTORS
VITUS

ACTORS & COMEDIANS
GENESIUS

ADVERTISING
BERNARDINE OF SIENA

ADVOCATES
IVO

AIR TRAVELERS
JOSEPH OF COPERTINO

ANESTHETISTS
RENÉ GOUPIL

ANGINA SUFFERERS
SWITHBERT

ANIMAL WELFARE SOCIETIES
FRANCIS OF ASSISI

APOLOGISTS
JUSTIN

ARCHERS
SEBASTIAN

ARCHITECTS
THOMAS

ARTISTS
LUKE

ASTRONAUTS & PILOTS
JOSEPH OF COPERTINO

ASTRONOMERS
DOMINIC

ATHLETES
SEBASTIAN

AUTHORS
FRANCIS DE SALES

BABIES
ZENO OF VERONA

BAKERS
*ELISABETH OF HUNGARY;
HONORATUS*

BANKERS
MATTHEW

BARBERS
COSMAS; DAMIAN

BARREN WOMEN
*ANTHONY OF PADUA;
FELICITY*

BEEKEEPERS
AMBROSE

BEGGARS
*ELISABETH OF HUNGARY;
GILES; MARTIN OF TOURS*

BELL-FOUNDERS
AGATHA

BLACKSMITHS
DUNSTAN

BLIND PEOPLE
DUNSTAN; LUCY; THOMAS

BOOKKEEPERS
MATTHEW

BOOKSELLERS
*JOHN THE EVANGELIST;
JOHN OF GOD; THOMAS
AQUINAS*

BOY SCOUTS
GEORGE

BREWERS
*AUGUSTINE; BONIFACE;
LUKE*

BRICKLAYERS
STEPHEN

BRIDES
*DOROTHY; NICHOLAS OF
MYRA*

BUILDERS
BARBARA

BUTCHERS
ANTHONY

CABINET-MAKERS
ANNE

CANDLE-MAKERS
*AMBROSE; BERNARD OF
CLAIRVAUX*

CARPENTERS
JOSEPH

CHILDREN
NICHOLAS OF MYRA

CHOIRBOYS
DOMINIC SAVIO

COOKS
LAWRENCE; MARTHA

COPPERSMITHS
MAURA

CRIPPLES
GILES

DENTISTS
APOLLONIA

DOCTORS
LUKE

ECOLOGISTS
FRANCIS OF ASSISI

ENGINEERS
JOSEPH

FATHERS
JOSEPH

FIREMEN
FLORIAN

FISHERMEN
ANDREW

FLORISTS
THÉRÈSE OF LISIEUX

FUNERAL DIRECTORS
JOSEPH OF ARIMATHEA

G

GARDENERS
DOROTHY

GOLDSMITHS
DUNSTAN

Continued on page 45

MARCH

ATRICK, THE MUCH

loved patron saint of Ireland, is the earliest of the British saints. Among his writings that still survive from the first half of the fifth century are some of his prayers.

 May the strength of God pilot us.
May the power of God preserve us.
May the wisdom of God instruct us.
May the hand of God protect us.
May the way of God direct us.
May the shield of God defend us.
May the hosts of God guard us against
the snares of the Evil One
and the temptations of the world.
May Christ be with us. Christ before us.
Christ in us. Christ over us.
May thy salvation, O Lord, be always ours
this day and for evermore.

ST. PATRICK

✷ MARCH ✷

DAVID
(DIED C. 600) BISHOP

*D*AVID, patron saint of Wales, founded Mynyw (Menevia) monastery, where monks followed a very austere rule, based on that of the Egyptian monks. David is traditionally known as "the Waterman," perhaps because his monks were teetotalers. He is associated with the leek and the daffodil (perhaps because his name in Welsh is Dafydd), and in art his symbol is a dove.

CHAD
(DIED 673) BISHOP

THE brother of St. Cedd, Chad was educated at Lindisfarne, off the northeast coast of England, under Aidan. He became Bishop of York, but because his consecration was later held to be irregular he left York, in very good grace, and later became Bishop of the Mercians. Bede wrote of him that "he administered his diocese in great holiness of life." In art he often holds a church.

AELRED
(1110–1167) ABBOT

AELRED was thought of as a saint in his own lifetime because of his preaching and his holy life. He was Abbot of Reversby and Rievaulx. Though a severe ascetic himself, he dealt gently with all his monks, none of whom he dismissed in 17 years.

CASIMIR OF POLAND
(1458–1484) CONFESSOR

ALTHOUGH Casimir was the second son of King Casimir IV of Poland, he refused to attack Hungary and take its throne, so he was confined to a castle. Casimir is the patron saint of Poland and Lithuania and is remembered for his life of piety and prayer.

✳ MARCH ✳

ADRIAN
(DIED 309) MARTYR

*A*DRIAN and his companion Eubulus visited a group of Christians in Caesarea and were tortured and martyred, on March 5 and March 7 respectively, under the governor Firmilian.

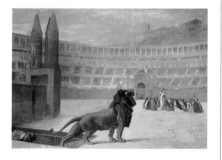

WILFRED
(8TH CENTURY) MONK

THIS monk-hermit of Lindisfarne was a goldsmith by trade. He used gold, silver, and gems to bind Cuthbert's copy of the Gospels of Lindisfarne.

PERPETUA
AND FELICITY
(DIED 203) MARTYRS

ALONG with Felicity and four Christian men, Perpetua, a nursing mother in her twenties, was martyred in Carthage in an arena full of wild animals. As they entered the arena they shouted out, "You judge us: God will judge you!"

JOHN OF GOD
(1495–1550) FOUNDER

JOHN was born at Granada, in Portugal, and had such extreme conversion experiences that he was thrown into prison for being mad. He gave himself to serving God by caring for the homeless and the poor. He was condemned for taking in prostitutes. After his death the Brothers of St. John of God, an order of hospitalers, was founded in his memory.

✳ MARCH ✳

GREGORY OF NYSSA
(DIED C. 395) BISHOP

GREGORY'S older brother, Basil the Great, nominated him to become Bishop of Nyssa. Of the three "great Cappadocians" (the other two being Basil and Gregory Nazianzen), Gregory of Nyssa was the most profound writer and thinker and was called by the second General Council of Nicaea (680–681) "Father of the Fathers."

THE FORTY MARTYRS
(320) MARTYRS

EMPEROR Licinius ordered all Christians to forsake their religion or be killed. One legion, named the "Thunderstruck," had 40 Christian soldiers who refused to disown their Lord. They were stripped naked and forced on to a frozen pond one night. The few who survived the night were then put to the sword by their fellows.

MARGARET TERESA REDI
(1747–1770) NUN

MARGARET was sent to the St. Apollonia convent in Florence at the age of 10. She became a Discalced Carmelite at St. Teresa Convent at the age of 18, and devoted the rest of her life to prayer.

PETER THE DEACON
(DIED C. 605) MONK

A BENEDICTINE monk, Peter dedicated his life to being Gregory the Great's companion, disciple, and secretary. He wrote down Gregory's four books of *Dialogues*.

✳ MARCH ✳

RODERIC
AND SOLOMON
(DIED 857) MARTYRS

RODERIC was persecuted by his two brothers. One of them, a Muslim, paraded him through the streets of Cabra in Spain, saying Roderic wanted to become a Muslim. Roderic was put in prison, where he met another Christian, Solomon, with whom he was beheaded.

MATILDA
(DIED 968) WIDOW

THE wife of the German king Henry the Fowler, Matilda founded the Benedictine abbeys of Engern, Pohlde, Nordhausen, and Quedinburg.

CLEMENT MARY
HOFBAUER
(1751–1820) FOUNDER

BORN in Tasswitz in Moravia, Clement Hofbauer joined the Redemptorists in Rome and then worked with them in Warsaw, Poland. At St. Benno's he founded the first Redemptorist religious house in Poland, where he became renowned for his pastoral and preaching ministries.

JULIAN OF ANTIOCH
(DIED C. 302) MARTYR

SOMETIMES called Julian of Anazarbus, Julian suffered under Diocletian's persecution of the Christians. He was tied up in a sack full of scorpions and vipers and then drowned at sea.

✳ MARCH ✳

PATRICK
(c. 385–c. 461) BISHOP

*A*T the age of 16 Patrick was captured by pirates, sold as a slave in Ireland, and forced to become a herdsman for six years, before he managed to escape to the Continent. In fulfillment of a dream he returned to Ireland, in 431, to many years of successful evangelism, during which he founded scores of churches and became the first Bishop of Armagh.

CYRIL
(c. 315–386) BISHOP AND TEACHER

ALTHOUGH Cyril became Bishop of Jerusalem, he spent many periods in exile from Jerusalem, amounting to 17 years in all, because of the opposition of the Arians. He is remembered for his work as a teacher of the Christian faith. He gave profound and popular lectures to people preparing for baptism.

JOSEPH
(1ST CENTURY) PATRON

MATTHEW's and Luke's Gospels tell us all we know for certain about the husband of the Virgin Mary. He was a "righteous man" who "did not want to expose Mary to public disgrace" (Matthew 1:19). God spoke to him and guided him through dreams concerning the birth and safety of Jesus.

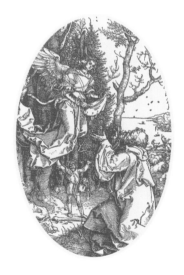

✳ MARCH ✳

CUTHBERT
(c. 634–667) BISHOP

BEDE often refers to Cuthbert as "the child of God" on account of his life of holiness, which was spent in visiting, preaching, helping the poor, and giving wise counsel. As Bishop of Lindisfarne, he spent his last two years caring for those who had caught the plague, which decimated his diocese.

SERAPION
(DIED C. 370) BISHOP

SERAPION is often considered a martyr, since he died in exile after supporting St. Athanasius in the Arian controversy. He was head of the catechetical school in Alexandria, where his learning rightly earned him the title of "the Scholastic." He retired to the desert where he made friends with St. Antony.

NICHOLAS OWEN
(DIED 1606) MARTYR

OWEN was canonized by Pope Paul VI in 1970 and is known as one of the Forty Martyrs of England and Wales. Born in Oxford, Owen used his skills as a carpenter to build hiding places in country mansions for persecuted Jesuit priests. He was imprisoned in the Tower of London and died after a series of severe tortures.

TORIBIO ALFONSO DE MOGROBEJO
(1538–1605) BISHOP

BORN at Mayorga, in Spain, Alfonso became the chief judge of the inquisition court at Granada. Although a layman, he was appointed Archbishop of Lima in Peru, in 1581, a year before he went there. In Lima he learned the Indian dialects, defended the Indians from being abused, and worked tirelessly on behalf of the poor and sick, founding schools and hospitals. He was also known for being a remarkable preacher.

✶ MARCH ✶

OSCAR ROMERO

(1917–1980) ARCHBISHOP AND MARTYR

BEING Archbishop of San Salvador did not prevent Romero from being murdered by a single assassin's bullet, just after he had preached during a church service. He was a champion of the poor and exposed the constant abuse of human rights. It is widely believed that the authorities ordered the killing of this man who said that "no soldier is obliged to obey an order that is contrary to the law of God."

ANNUNCIATION OF THE LORD

THE words of the angel Gabriel, spoken to the Virgin Mary, announcing the birth of Jesus, are recorded by Luke: "Do not be afraid, Mary, you have found favor with God. You will be with child and give birth to a son, and you are to give him the name Jesus."

LUKE 1:30

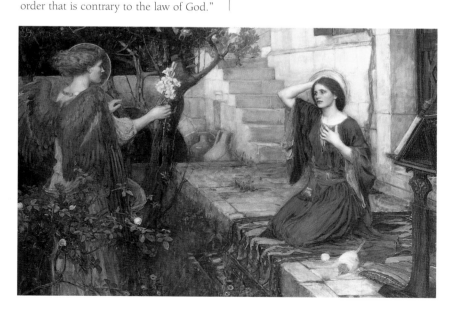

✳ MARCH ✳

BASIL THE YOUNGER
(852–952) HERMIT

ASIL lived as an anchorite near Constantinople, but was arrested and tortured, accused of being a spy. He was eventually released and exercised a healing and prophetic ministry.

JOHN THE EGYPTIAN
(C. 304–394) HERMIT

JOHN, a carpenter by trade, became a hermit in middle age and was renowned for his holy life. He had the gift of foretelling the future and was consulted twice by Emperor Theodosius I.

TUTILO
(DIED C. 915) MONK

TUTILO, a very accomplished and obedient monk, lived at St. Gall in Switzerland. He was a gentle giant, being very strong and tall, a poet and orator, as well as an architect, painter, and mechanic. He was a gifted musician and taught at the abbey school.

✳ MARCH ✳

RUPERT
(*DIED C. 710*) BISHOP

HEN he died at Salzburg, Rupert was considered Salzburg's first bishop. He had built a school there and the first church and monastery. Rupert helped most of the population of Bavaria to embrace the Christian faith, including Duke Thodo. He changed pagan temples into Christian churches and introduced many missionaries.

BENJAMIN
(*DIED C. 421*) MARTYR

BENJAMIN, the deacon, was imprisoned under Yezdigerd of Persia's persecution, for preaching. The Emperor of Constantinople arranged for his release, but Benjamin continued to preach. He was arrested and, refusing to give an undertaking to stop preaching if released, he was killed.

AMOS
OLD TESTAMENT PROPHET

The Byzantine calendar delights in remembering people from the Old Testament. Amos, one of the 12 minor prophets, wrote as a champion of the poor and passionately exposed social injustice and all "who trample on the heads of the poor."

AMOS 2:7

APRIL

HE FIRST PEOPLE TO
to be remembered as "saints" by the early Church were Christian
martyrs. Christians held services on the anniversary of the
martyrs, deaths, if possible, at their grave sites, and celebrated the person's life
and martyrdom. Martyrdom became something of a cult, so if you underwent
martyrdom you were thought to be a particularly holy Christian. Christians
were in the first line of attack from the Roman emperors in the early centuries,
until Constantine became emperor, as this quotation from Tertullian illustrates:

> If the River Tiber reaches the walls,
> if the River Nile does not rise to the fields,
> if the sky does not move or the earth does,
> if there is famine,
> if there is plague,
> the cry is at once:
> "The Christians to the lion!"
> What, all of them to one lion?

TERTULLIAN, *APOLOGY*

✳ APRIL ✳

MACARIUS
(DIED 830) WONDER-WORKER

B ORN in Constantinople, and remembered for the miracles he performed, Macarius suffered torture and imprisonment under two emperors, Leo the Armenian and Michael the Stammerer.

FRANCIS OF PAOLA
(C. 1436–1507) FOUNDER

RANCIS, patron of seafarers, became a hermit at the age of 14. The disciples who gathered around this spiritually gifted man, who could read people's minds, founded a community at Paola in Italy, which grew into a new order of Minim Friars (*minimi fratres*, the "least brethren"), with a rule of life that was particularly austere.

RICHARD OF CHICHESTER
(C. 1197–1253) SCHOLAR

ICHARD de Wych, Bishop of Winchester, had supported Edmund, Archbishop of Canterbury, in his struggles against King Henry III's misuse of Church funds. Richard died at Dover, carrying out the Pope's orders to go to the Crusades. He is remembered for his prayer:

"…May I know thee more clearly, love thee more dearly, and follow thee more nearly; day by day."

ISIDORE OF SEVILLE
(C. 560–636) PHILOSOPHER

I SIDORE, from Cartagena in Spain, is thought of as the last of the ancient Christian philosophers. He founded schools in each diocese in Spain and completed Leander's Mozarabic liturgy. He was known for his personal austerity and generosity to the poor, was canonized in 1598 and made a Doctor of the Church in 1722.

✳ APRIL ✳

VINCENT FERRER
(1350–1419) CONFESSOR

THIS remarkable Dominican succeeded in resolving the scandal of a divided Western Church, when three people all claimed the right to be Pope. He became confessor to the Avignon Pope and persuaded him to resign, along with the two other claimants, thus allowing Martin V to be elected by all.

MARCELLINUS
(DIED C. 413) MARTYR

MARCELLINUS attempted to enforce the measures of the Council of Carthage against the heretical Donatists. He was then executed without trial, accused of being a traitor to Rome. Augustine dedicated *The City of God* to "My dear friend Marcellinus."

JOHN BAPTIST
DE LA SALLE
(1651–1719) FOUNDER

BORN in Rheims in France, John is remembered for his pioneering educational work, which started when he opened a school for poor boys in 1679. In the teeth of bitter opposition, he managed to introduce his original teaching principles, that classroom teaching should replace individual teaching, and that teaching should be in the vernacular and not in Latin.

DIONYSIUS OF
CORINTH
(DIED C. 180) BISHOP

AS Bishop of Corinth, Dionysius was a leading Christian figure in the second century. He is especially remembered for a letter he wrote to the Roman Christians, recording the martyrdoms of Peter and Paul.

✳ APRIL ✳

MARY OF CLEOPHAS
(1ST CENTURY) MATRON

MARY, the wife of Clopas (John 19:25), and mother of James and John (Matthew 27:56), watched Jesus being crucified and went with Mary Magdalene to Christ's tomb on the first Easter Day.

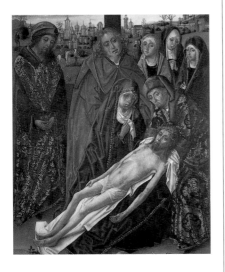

BADEMUS
(DIED 376) FOUNDER AND MARTYR

BADEMUS founded and became abbot of a monastery near his birthplace of Bethlapat in Persia. King Sapor II had Bademus persecuted and imprisoned, with seven of his monks. A one-time Christian, named Nersan, murdered Bademus because he was promised his freedom if he did so.

STANISLAUS
(1030–1079) BISHOP AND MARTYR

STANISLAUS' preaching and spiritual guidance were greatly appreciated while he was Bishop of Cracow, Poland. He opposed King Boleslaus the Bold (or the Cruel) for kidnapping a nobleman's wife and excommunicated him because of his cruelties. The king then retaliated by killing Stanislaus as he led a church service.

✳ APRIL ✳

APRIL 12

SABAS THE GOTH
(DIED C. 372) MARTYR

SABAS, a Goth, was converted to Christ in his youth. He survived two persecutions of Christians, but during a third wave of persecution was tortured and then drowned in the Mussova River near Targoviste. Fifty other Christians were also martyred at this time.

APRIL 13

MARTIN I
(DIED 655) POPE

MARTIN was the last Pope to be honored as a martyr, although he actually died in exile. He opposed Constans II, the Byzantine emperor, who had Martin brought to Constantinople from Rome. Although Martin was very ill, he was tried, convicted, treated most harshly, and died in prison. In one of his letters Martin wrote,

"For 47 days I have not been given water to wash in. I am frozen with cold and overtaken by dysentery. The food I am given makes me sick. But God, in whom I trust, sees everything."

APRIL 14

LYDWINA
(1380–1433) VISIONARY

LYDWINA, born at Schiedam in Holland, suffered a painful, permanent injury as a result of an ice-skating accident when she was 16. She determined to bear her ever-increasing pain as reparation for the sins of others. During the last 17 years of her life she had many visions, especially of Christ's passion and of heaven.

APRIL 15

HUNNA
(DIED C. 697) MATRON

THE wife of a nobleman, Hunna devoted her life to caring for the needy of Strasbourg, where she became known as the "holy washerwoman" because she even washed the poor.

✳ APRIL ✳

BENEDICT JOSEPH LABRE
(1748–1783) PILGRIM

B ENEDICT Labre was born at Amettes in France, and made many pilgrimages to the major shrines in Europe. In 1774 he lived in the Colosseum, in Rome, where he became known as "the beggar of Rome" on account of his holy way of life and his poverty. He was canonized in 1883.

APOLLONIUS THE APOLOGIST
(DIED C. 185) MARTYR

A SLAVE reported Apollonius to a praetorian prefect, Perennis, for being a Christian. Apollonius would not renounce his faith and was tried by the Senate, where a memorable dialogue took place between him and Perennis. Despite his eloquent defense, Apollonius was condemned and beheaded.

KATERI TEKAKWITHA
(C. 1656–1680) LIFE OF PIETY

K ATERI was born at the Indian village of Osserneon (Auriesville), New York. Her father was a Mohawk chieftain, and Kateri was despised and abused when she converted to Catholicism in 1676. She made a 200-mile trek to the Christian Indian village of Sault Ste Marie, near Montreal in Canada, where she became known for her life of holiness and austerity.

ALPHEGE
(C. 945–1012) ARCHBISHOP AND MARTYR

A BENEDICTINE monk at Deerhurst monastery in Gloucestershire, England, Alphege cared for the poor to eliminate poverty in the diocese of Winchester when he became bishop there. As Archbishop of Canterbury he cared for those suffering from plague, but refused to ransom himself from the Danish invaders with money from the poor and was killed at Greenwich.

✳ APRIL ✳

JAMES THE GREATER
(DIED 42) APOSTLE AND MARTYR

*J*AMES, son of Zebedee and brother of the beloved disciple John, was a member of the inner circle of three of Jesus' 12 disciples who were with Jesus at the raising of Jairus' daughter and at Jesus' transfiguration, and who were meant to pray with him in the garden of Gethsemane. James was the first of the apostles to be martyred, being beheaded by Herod Agrippa I in Jerusalem.

ANSELM
(1033–1109) MONK AND ARCHBISHOP

*A*NSELM, born in Aosta in northern Italy, a monk and philosopher, became Archbishop of Canterbury and had to oppose King William Rufus and Henry I. He championed the plight of the poor and was one of the first people to oppose the slave trade.

EPIPODIUS
AND ALEXANDER
(DIED 178) MARTYRS

*T*HESE two Christians tried to escape from Lyons when Marcus Aurelius persecuted the Christians who lived there. They were caught and Epipodius was beheaded. Alexander died after two days of torture on a cross.

GEORGE
(DIED C. 303) MARTYR

*L*ITTLE is known for certain about England's patron saint, George, except for the fact that he was martyred at Lydda, in Palestine, before Constantine became emperor. The story that he slew a dragon did not appear before the 12th century, but gained appeal with its inclusion in *The Golden Legend.*

✳ APRIL ✳

FIDELIS OF SIGMARINGEN
(1577–1622) MARTYR

PRACTICING as a lawyer in Germany, Mark Rey, who was born at Sigmaringen, was known as the "advocate of the poor," or "poor man's lawyer." He became a Capuchin monk, was given the name Fidelis, and went as a missionary to Switzerland. He was stabbed to death in a church, probably by some Protestants who were jealous of his success.

MARK
(DIED C. 74) EVANGELIST

MARK the son of Mary, whose home in Jerusalem became a place of rest for Jesus and his 12 apostles, is the traditional author of the second Gospel. Papias, in 130, said that he wrote as Peter's interpreter, and it is possible that Mark gleaned much information about Jesus' life from Peter. Mark's Gospel is the earliest account we have of the life of Jesus.

RICHARIUS
(DIED C. 645) ABBOT

BORN at Celles, near Amiens in France, Richarius founded an abbey there. The present town of Abbeville is named after his abbey. He was probably the first person to devote his life to ransoming captives. He became a hermit in his old age and the monastery of Forest Montiers marks this place.

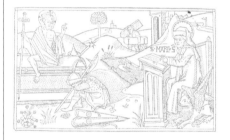

✳ APRIL ✳

MAUGHOLD
(DIED C. 498) MISSIONARY AND BISHOP

A N outlaw who became a convert of Patrick of Ireland, Maughold (also known as Maccul) was sent off to sea in a rudderless boat as a penance. He landed on the Isle of Man, became a very successful missionary, and was noted for his austerity. He was acclaimed bishop by the Manx people.

PETER CHANEL
(1803–1841) MISSIONARY AND MARTYR

A s a member of the Society of Mary (Marist Fathers), Peter was sent to the New Hebrides in the Pacific Ocean. On Fortuna Island the chief's son asked to be baptized, and the chief became so angry that he had Peter murdered. Peter was the first Marist missionary of Oceania.

CATHERINE OF SIENA
(1347–1380) TEACHER

T HIS Dominican mystic is the patron of nurses and patron saint of Italy. She once heard Jesus' voice in a vision say, "I draw closer to you through your love for others." As a nurse in Siena hospital, Catherine cared for the patients with the worst leprosy and terminal cancer.

PIUS V
(1504–1572) POPE

A NTONIO Michael Ghislieri, born at Bosco, near Alessandria in Italy, became inquisitor general of the whole Catholic Church in 1559. In 1566 he became Pope and set about completing the new catechism, restoring the simplicity of the papal court, reforming the missal, and organizing a complete new edition of the works of Thomas Aquinas. He lived a life of personal austerity, giving large amounts of money to the poor.

The Saints as Patrons of People

HAIRDRESSERS
MARTIN DE PORRES

HOSPITAL ADMINISTRATORS
BASIL THE GREAT

HOTEL KEEPERS
JULIAN THE HOSPITALLER

HOUSEWIVES
ANNE

JOURNALISTS
FRANCIS DE SALES

LAWYERS
THOMAS MORE

LIBRARIANS
JEROME

LOVERS
VALENTINE

MASONS
THOMAS (APOSTLE)

MERCHANTS
NICHOLAS

MISSIONS
FRANCIS XAVIER

MOTHERS
MONICA

MOTORISTS
CHRISTOPHER

MUSICIANS
CECILIA; GREGORY THE GREAT

NURSES
AGATHA; CAMILLUS; CATHERINE OF SIENA

PAINTERS
LUKE

PAWNBROKERS
NICHOLAS OF MYRA

PHILOSOPHERS
CATHERINE

PILGRIMS
JAMES

POETS
CECILIA; DAVID

POOR
ANTHONY OF PADUA; LAWRENCE

POSTMEN
GABRIEL (ARCHANGEL)

POTTERS
SEBASTIAN

PREACHERS
JOHN CHRYSOSTOM

PRINTERS
JOHN THE EVANGELIST

PUBLISHERS
JOHN THE EVANGELIST

SCULPTORS
LUKE

SHEPHERDS
CUTHBERT

SHOEMAKERS
CRISPIN; CRISPINIAN

SILVERSMITHS
DUNSTAN

SINGERS
CECILIA

SOLDIERS
IGNATIUS LOYOLA

STUDENTS
JEROME

SURGEONS
LUKE

TAILORS
JOHN THE BAPTIST

TAX COLLECTORS
MATTHEW

TEACHERS
URSULA

THEOLOGIANS
AUGUSTINE

TRAVELERS
CHRISTOPHER

VINE-GROWERS
VINCENT OF SARAGOSSA

WRITERS
FRANCIS DE SALES

MAY

 ERE IS A BLUEPRINT
*for how Christians should regard saints, according to the leading
Strasbourg reformer Martin Bucer (1491–1551), who became a
Regius Professor in Cambridge.*

*We teach that the blessed saints who lie in the presence of our Lord
Christ and of whose lives we have biblical or other trustworthy
accounts, ought to be commemorated in such a way that the
congregation is shown what graces and gifts their God and Father and
ours conferred upon them through our common Savior and that we
should give thanks to God for them, and rejoice with them as
members of the one body over those graces and gifts, so that we may
be strongly provoked to place greater confidence in the grace of God
for ourselves, and to follow the example of their faith.*

BUCER, BRIEF SUMMARY OF CHRISTIAN DOCTRINE

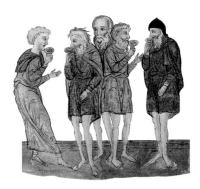

✳ MAY ✳

BRIEUC
(DIED C. 510) FOUNDER

BRIEUC, Brioc, or Briomaglus, was born in Cardiganshire, Wales. He gathered around him 168 disciples who worked as pastors and evangelists in England and then in Brittany, where he founded two abbeys, one at Tréguier and one at Saint-Brieuc.

MAFALDA
(1204–1252) NUN

MAFALDA, daughter of King Sancho I of Portugal, joined the Arouca Convent as a Benedictine nun, lived a life of great austerity, and was responsible for the convent's adopting the Cistercian rule. With large donations of money from her father, Mafalda built a home for widows and a hostel for travelers and restored Oporto Cathedral.

PHILIP AND JAMES
(1ST CENTURY) APOSTLES

Philip was born in Bethsaida, Galilee, and, except for the lists of the apostles, is mentioned only by John. In reply to a question from Philip, Jesus said: "Anyone who has seen me has seen the Father" (John 14:9).

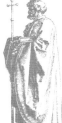

James, the son of Alpheus, became the leader of the early Church in Jerusalem.

GOTHARD
(c. 960–1038) BISHOP

GOTHARD, or Godehard, became Abbot of Nieder Altaich, in Bavaria. He ruled this Benedictine house so well that Emperor Henry II allowed him to reform several other monasteries. When he was made Bishop of Reichersdorf, in 1022, he continued his reforming work, especially of the cathedral school. The railway tunnel from Switzerland to France is named after him.

✳ MAY ✳

JUTTA
(DIED 1260) WIDOW

JUTTA was born at Sangerhausen, Thuringia. After her husband died on a pilgrimage, she gave away all her money to the poor and devoted her life to caring for the sick. She had numerous visions, and is reputed to have performed healing miracles and experienced levitation.

EVODIUS
(DIED C. 67) BISHOP AND MARTYR

TRADITION places Evodius as the Bishop of Antioch, consecrated by Peter, and as one of the 72 disciples of Christ. He is said to have been the first person to use the word "Christian."

SERENICUS
AND SERENUS
(DIED C. 669; DIED 680) HERMITS

THESE brothers lived as hermits near the Sarthe River, Maine, in Gaul, and their holy lives soon attracted many followers. Serenicus then became the leader of a community of 140 men, but his brother Serenus remained a hermit until his death.

JULIAN OF NORWICH
(C. 1342–1423) ANCHORESS

JULIAN, or Juliana, lived for over 40 years in a cell attached to the church of St. Julian and St. Edward at Conisford near Norwich, England. She had a series of 16 revelations which she recorded in *Revelations of Divine Love*. Through one of her revelations, she wrote,

"God is closer to us than our own soul; for he is the ground in whom our soul stands. For our soul rests in God and our soul stands in God in sure strength, and our soul is rooted in God's endless love."

✳ MAY ✳

PACHOMIUS
(c. 292–348) FOUNDER

PACHOMIUS, born in Upper Thebaid in Egypt, became a disciple of the hermit Palaemon. Pachomius attracted so many followers that he founded a community for them. Later he founded a further six communities for men and a convent for his sister. St. Benedict used Pachomius' Rule in writing his own famous monastic rule.

ANTONINUS OF FLORENCE
(1389–1459) FOUNDER AND ARCHBISHOP

ANTONINUS, or Anthony Pierozzi, born in Florence in Italy, founded the famous San Marco Convent at Florence, where he became archbishop in 1446. He forbade sorcery and gambling and helped the victims of the plague, famine, and earthquake in his diocese. He also became known as "the Counselor" because of his knowledge of canon law.

MAMERTIUS
(DIED C. 475) ARCHBISHOP

AS Archbishop of Vienne, Mamertius started the practice of holding three Rogation days before Ascension Day. On these days Christians processed, sang psalms, and prayed for God's protection against the many illnesses that afflicted the people of Vienne.

NEREUS AND ACHILLES
(1ST CENTURY) MARTYRS

NEREUS and Achilles, two praetorian soldiers, were converted to Christianity and then refused to stay in the army. During Emperor Trajan's reign they were captured on the island of Terracina and beheaded.

✳ MAY ✳

JOHN THE SILENT
(454–558) BISHOP AND HERMIT

JOHN, born in Nicopolis, Armenia, founded and became superior of a monastery while still a teenager. He became Bishop of Colonia in Armenia. Nine years later he went to Jerusalem and lived in St. Sabas' laura, a group of detached cells where hermits lived under the rule of a superior. When he died John had spent 75 years of his life as a solitary.

MATTHIAS
(1ST CENTURY) APOSTLE

THE only reliable information about Matthias comes in Acts 1:21–26, which describes how he was chosen to "take over this apostolic ministry, which

Judas left…They cast lots, and the lot fell on Matthias; so he was added to the 11 apostles." It is believed that he was martyred at Colchis.

HALLVARD
(DIED 1043) MARTYR

HALLVARD, patron saint of Oslo, traded in the Baltic islands. A woman took refuge on his ship, and in an attempt to defend her against three men both the woman and Hallvard were killed by arrows. Hallvard is recognized as a martyr because he was defending an innocent person.

SIMON STOCK
(c. 1165–1265) FOUNDER

LEGEND has it that Simon is surnamed Stock because he lived in a tree trunk in his youth. Born in Kent, in southeast England, Simon became a Carmelite and later the sixth general of this order. He helped to establish Carmelite houses in many principal university cities of Europe, including Bologna, Paris, Oxford, and Cambridge.

✳ MAY ✳

ST. BRUNO PRAYING

MAY 17

BRUNO
(DIED 1045) BISHOP

BRUNO, the saintly Bishop of Würzburg, encouraged church building and the restoration of churches throughout his diocese, contributing generously to this from his own private wealth. He died when a building collapsed on him.

MAY 18

JOHN I
(DIED 526) POPE

JOHN, born in Tuscany in Italy, was elected Pope in 523. King Theodoric forced John I to try to modify Emperor Justin's decrees against the Arians. Justin and John I had a most friendly meeting, so when John returned to Italy, Theodoric was angry and had him imprisoned in Ravenna, where he died as a result of ill-treatment.

MAY 19

YVES KERMARTIN
(DIED 1303) JUDGE

YVES, or Ivo, Helory was born at Kermartin in France, and became a diocesan judge to the Bishop of Treguier. He was noted for his care and concern for the poor and ignorant. In 1284 he was ordained and lived a frugal life, freely giving his legal expertise to his parishioners.

⇒ *51* ⇐

✳ MAY ✳

BERNARDINO OF SIENA
(1380–1444) TEACHER

Bernardino, a Franciscan, excelled at preaching and became the most notable Italian missioner of his day. His favorite subject was the holy name of Jesus. He became the vicar-general of the Franciscans, whose numbers rose from 300 to 4,000 under his leadership.

HELENA
(c. 255–c. 330) EMPRESS

Helena, mother of Constantine, the first Roman emperor to be a Christian, visited Jerusalem in her old age and built basilicas on the Mount of Olives and at Bethlehem. She was reputed to have found a piece of the True Cross. Soldiers, poor people, and prisoners had reason to be grateful for her kindness.

AIGULF
(DIED 836) BISHOP AND HERMIT

Aigulf was born at Bourges in France and became a hermit after the death of his parents. Because of his holy life he was acclaimed Bishop of Bourges.

DESIDERIUS
(DIED 607) BISHOP AND MARTYR

Desiderius became Bishop of Vienne and attacked the many prevailing abuses in the Church, especially simony. As a latter-day John the Baptist, Desiderius exposed the immorality of the court of Queen Brunhildis. He also publicly censured King Theodoric, who promptly had him murdered.

✳ MAY ✳

DONATIAN
(DIED C. 300) MARTYR

DONATIAN lived at Nantes in Brittany, with his family, and was accused of being a Christian under Emperor Maximian's persecution of the Christians. He was imprisoned for not sacrificing to the gods when told to and, along with his brother Rogatian, was tortured before being beheaded.

THE VENERABLE BEDE
(C. 672–735) HISTORIAN

KNOWN as the "Father of English History," Bede spent nearly all his life at Jarrow, in northeast England, "always writing, always praying, always reading, always teaching." He was probably called "Venerable" because he was both a priest and a monk. His best-known book, *Historia Ecclesiastica*, is a history of the English Church and people. He died dictating the last sentence of his translation of John's Gospel.

PHILIP NERI
(1515–1595) FOUNDER

PHILIP, from Florence in Italy, founded the Confraternity of the Most Holy Trinity, which became the well-known Santa Trinita dei Pellegrini Hospital, caring for pilgrims in need. Philip became the most popular person in Rome, was renowned for his miracles and kindness, and became known as "the Apostle of Rome." He was canonized in 1662.

DEATH OF THE VENERABLE BEDE

∗ MAY ∗

AUGUSTINE OF CANTERBURY
(DIED 604) ARCHBISHOP

Born in Rome, Augustine was sent in 596 by Pope Gregory the Great to evangelize the English. He built a Benedictine monastery church at Canterbury and became its first archbishop; he is known as "the Apostle to the English."

GERMANUS
(C. 496–576) BISHOP

Germanus, born at Autun, in France, became abbot of St. Symphorian Abbey in Autun, before becoming Bishop of Paris in 554. In Paris, Germanus condemned the immorality of the court and was noted for his own generosity and work of evangelization.

CYRIL OF CAESAREA
(DIED C. 251) MARTYR

As a young boy, Cyril became a Christian and was turned out of his home. The governor of Caesarea arrested him and gave him the opportunity to offer a sacrifice to the gods, but Cyril refused and so was beheaded.

JOAN OF ARC
(C. 1412–1431) MARTYR

As a 17-year-old peasant girl at Domrémy in Lorraine, Joan heard voices of saints in her head telling her to help King Charles VII of France to rid their country of the English. She dressed in a suit of white armor, and her inspiration and bravery virtually saved France and had Charles crowned at Rheims. However, the Burgundians sold Joan to the English, who burned her at the stake.

✳ MAY ✳

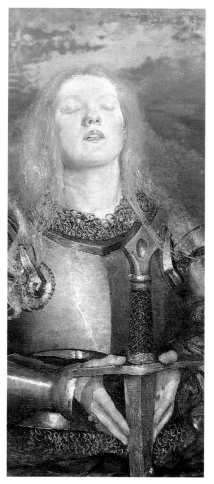

JOAN OF ARC

VISIT OF THE BLESSED VIRGIN MARY TO ELIZABETH

Elizabeth was visited by her cousin Mary, who spoke the hymn of praise that we now call the Magnificat. Just before this, Elizabeth said to Mary: "Blessed are you among women, and blessed is the child you will bear! ...As soon as the sound of your greeting reached my ears, the baby in my womb leaped for joy."

LUKE 1:42, 44

JUNE

 ELTIC CHRISTIANITY
is being rediscovered by many at the end of the 20th century. Celtic prayers, such as this example written by Columba, are especially appreciated.

> Be thou a bright flame before me,
> Be thou a guiding star above me,
> Be thou a smooth path below me,
> Be thou a kindly shepherd behind me,
> Today – tonight – and forever.

COLUMBA

✷ JUNE ✷

JUSTIN MARTYR
(c. 100–c. 165) APOLOGIST AND MARTYR

Justin is known as the most important early "apologist," who offered a reasoned defense for Christianity, explaining that it was the fulfillment of the Old Testament prophecies. Justin, with six other believers, was martyred. As he had previously said to the emperor, *"You can kill us, but not hurt us."*

APOLOGY 2.4

POTHINUS
(DIED 177) BISHOP AND MARTYR

At the age of 90, Pothinus was the leader of the martyrs of Lyons. Despite his age and frailty, he was taken to court, where the governor asked him who the Christian God was. Pothinus replied, "If you are worthy, you shall know." For this he was beaten up and thrown into prison, where he died two days later.

MARTYRS OF UGANDA
(1886)

Sir Charles Lwanga was burned alive by King Mwanga of Uganda for refusing the king's sexual advances. Thirty of his companions, aged from 13 to 30, were given the choice of giving in to the king's wishes or being burned alive. They were all tied up and slowly roasted to death.

CLOTILDA
(c. 474–545) QUEEN

Clotilda, daughter of the King of Burgundy, married Clovis, King of the Franks, and converted him to Christianity. After his death Clotilda devoted her life to caring for the poor and sick.

⋆ JUNE ⋆

BONIFACE

(c. 680–754) BISHOP AND MARTYR

BONIFACE, "the Apostle of Germany," was born in Crediton in southwest England. He felt called to evangelize Germany, where he met paganism head on. With help from monks and nuns from England he founded Christian schools and monasteries in Germany. He was martyred by an uncontrolled armed mob as he camped for the night on his way to a confirmation at Dokkum.

EDMUND IGNATIUS RICE

(1762–1884) FOUNDER

UPON the death of his wife in 1789, Edmund devoted himself to a life of good deeds. He founded the Congregation of the Brothers of the Christian Schools, for poor boys, in Waterford, Ireland. This congregation of lay people, known as Christian Brothers, spread throughout the world, and today their work includes looking after orphanages and homes for the deaf and blind.

MARY TERESA DE SOUBIRAN

(1835–1889) FOUNDRESS

SOPHIA Teresa Augustina Mary was born at Castelnaudary in France, and took the name Mary Teresa when she joined a community of laywomen in her hometown, at the age of 19. In 1864 she founded the Society of Mary Auxiliatrix at Toulouse, which cared for poor children and orphans.

MEDARD

(c. 470–c. 560) BISHOP

BORN in Picardy, in northern France, Medard became renowned for his preaching and energetic missionary activities and became Bishop of Vermadois in 530. A legend is linked with him similar to that of St. Swithun: that if it rains on Medard's day it will rain for 40 days, and if it is sunny on his feast day then 40 days of sunshine will follow.

✳ JUNE ✳

EPHRAEM
(C. 306–C. 373) DOCTOR OF THE CHURCH

*B*ORN at Nisibis in Mesopotamia, Ephraem became a deacon there, but took refuge in a cave near Edessa when the Persians captured Nisibis. He distributed food to the poor and was especially known for his writings. He is credited with introducing the singing of hymns into public worship.

LANDERICUS OF PARIS
(DIED C. 660) BISHOP

*L*ANDERICUS, or Landry, was appointed Bishop of Paris in 650. His devotion to the poor knew no bounds. He once sold items from a church to provide food for the poor during a famine. He founded St. Christopher's Hospital, which became the famous Hôtel-Dieu.

BARNABAS
(1ST CENTURY) APOSTLE

*A*ccording to Luke, Barnabas was: "a good man, full of the Holy Spirit and faith" (Acts 11:24). After Paul had been cold-shouldered by the Christians in Jerusalem, Barnabas "took [Paul] and brought him to the apostles." He told them about Paul's conversion experience and "how in Damascus he had preached fearlessly in the name of Jesus."

ACTS 9:27

ESKIL
(DIED C. 1080) MISSIONARY

*B*ORN in England, Eskil became a missionary in Sweden with Sigrid. When Sweyn the Bloody became king in Sweden, pagan practices were revived. Eskil opposed a pagan festival at Strangnas, where an altar was struck by lightning. Sweyn then accused Eskil of practicing magic and had him stoned to death.

✳ JUNE ✳

ANTHONY of PADUA
(1195–1231) TEACHER

ORN in Lisbon, Anthony set sail as a Friar Minor for Africa, longing for martyrdom. A storm drove his ship to Italy, where Francis of Assisi guided him into becoming an accomplished preacher with a remarkable knowledge of the Bible. Because of his sermons against heresy he earned the nickname "Hammer of the Heretics." He was equally well known for all the miracles he performed.

DOGMAEL
(6TH CENTURY) PREACHER

OGMAEL, most probably a Welshman, left Pembrokeshire for Brittany. He was noted for his saintly life, and several churches were named after him.

GERMAINE COUSIN
(c. 1579–1601) LIFE OF PIETY

ORN at Pibrac in France, Germaine lived a life of devotion, despite a paralyzed right hand, poor health, and ill-treatment from her stepmother. She became a shepherdess, and her neighbors witnessed her life of piety and reported miracles attributed to her.

JOHN REGIS
(1597–1640) PREACHER

EGIS, born at Fontcouverte in France, became a Jesuit in 1615. He was appointed to preach in southeastern France, where he always attracted very large crowds of people, bringing thousands back to the Christian faith. He also visited prisons and hospitals and cared for the needy.

✳ JUNE ✳

HERVE

(6TH CENTURY) ABBOT

HERVE, or Harvey, was born blind in Brittany, where he became head of a monastery. He later moved to Lanhouarneau and founded a new monastery, remaining there until his death. He led a quiet, holy life, performing numerous miracles.

MARCELLIAN

(DIED C. 287) MARTYR

LEGEND relates how Marcellian and his twin brother Mark were two deacons who lived in Rome. Chromatius, a prefect's assistant, condemned them to be executed for not sacrificing to the gods. But during further questioning, Chromatius was converted, and the brothers were set free. However, Fabian, Chromatius' successor, executed them.

ROMUALD

(c. 950–1027) ABBOT

ROMUALD had a great influence among the monks of his day. After leaving the monastery of San Miniato, he visited many monasteries, teaching the values of the solitary life. He founded Fonte Avellana for hermits and a monastery at Camaldoli.

SILVERIUS

(DIED C. 537) POPE

SILVERIUS was born at Frosinone, Campania, in Italy. Son of Pope Hormisdas, he became Pope himself in 536. However, Vigilius was also proclaimed Pope and Vigilius' followers captured Silverius and exiled him to the island of Palmarola, near Naples. Silverius was either starved to death or murdered there.

✴ JUNE ✴

ALOYSIUS GONZAGA
(1568–1591) CARER

*B*ORN in Lombardy, in northern Italy, Aloysius served as a Jesuit for six years, caring for those who were struck down with the plague in Rome in a hospital that the Jesuits had opened for this purpose. After doing this for four years he caught the plague himself and died.

THOMAS MORE
(1478–1535) STATESMAN

*M*ORE, an English scholar, writer, and lawyer, became Henry VIII's Lord Chancellor. Henry turned to him to arrange the dissolution of his marriage to Catherine of Aragon. More feared that this would lead to a schism within the Church and so resigned his chancellorship, which eventually led to his execution. He was canonized in 1935.

ETHELDREDA
(DIED 679) ABBESS

*E*THELDREDA, also known as Audrey, became a nun at Coldingham Convent, even though she was born a princess, being the daughter of the King of the East Angles. She built a double monastery at Ely in 672, where she became abbess of the convent until her death. She was noted for her holy life and dedication to God.

JOHN THE BAPTIST
(1ST CENTURY) PREACHER AND MARTYR

*J*OHN is the only saint to be remembered three times in the Christian calendar, in commemoration of his conception, his birth (June 24), and his martyrdom. When John saw Jesus he said that Jesus was the "Lamb of God," and he is the only person to use this expression of Jesus. In art John is often depicted carrying a lamb, or with a lamb near him.

✴ JUNE ✴

PROSPER OF AQUITAINE
(C. 390–C. 465) WRITER

In response to a letter that Prosper wrote to St. Augustine in 428, Augustine wrote his works on predestination and perseverance. Prosper himself wrote a *Chronicle*, a universal history from creation to 455 (when the Vandals captured Rome).

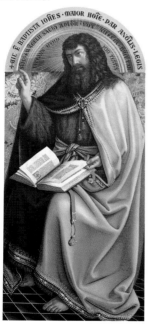

SALVIUS AND SUPERIUS
(DIED C. 768) MARTYRS

Salvius, a bishop in the district of Angoulême, in France, succeeded in a mission to evangelize the Flemish of Valenciennes, with his companion Superius. A local baron murdered them both, reputedly for their fine clothes.

CYRIL OF ALEXANDRIA
(C. 376–444) BISHOP AND TEACHER

Cyril was the most notable theologian of the Alexandrian tradition. His precise thinking and accurate writing are evident in his commentaries on Luke, John, and the Pentateuch; in his letters and sermons; and in his writings on dogmatic theology. Ethiopian Christians hold him up as their chief teacher.

✳ JUNE ✳

IRENAEUS
(c. 130–c. 200) BISHOP

IRENAEUS was the first great Christian writer in the West. He had a unique link with the apostles of Christ, because he was a disciple of Polycarp, who knew John the apostle. He successfully resisted an heretical doctrine of the second century, Gnosticism.

PETER AND PAUL
(1ST CENTURY) APOSTLES AND MARTYRS

Details of Peter's death come from the apocryphal Acts of Peter, according to which he was martyred upside down on a cross in Rome under Emperor Nero's persecution. While these details cannot be verified, they are consistent with Jesus' prediction about how Peter would die: "when you are old you will stretch out your hands" (JOHN 21:18–19). Jesus said this to indicate the way Peter would glorify God in death.

MARTIAL
(DIED C. 250) BISHOP

TRADITION says that Martial was one of the seven bishops sent from Rome to evangelize Gaul (France), where he founded Limoges and became its first bishop.

The Saints and Their Symbols in Art

AGNES
Lamb

AMBROSE
Bees, dove, ox

ANDREW
Transverse cross

APOLLONIA
Forceps, gripping tooth

BARBARA
Tower

BENEDICT
Raven

BERNARD
Bees, beehive

BONAVENTURE
Cardinal's hat

CATHERINE OF ALEXANDRIA
Wheel

CECILIA
Organ

CRISPIN
Crispinian shoe (or last)

DOROTHY
Flowers

DUNSTAN
Tongs

FRANCIS OF ASSISI
Birds, deer, fish, skull, stigmata, wolf

FRANCIS XAVIER
Bell, crucifix, ship

GENEVIÈVE
Bread, candle, herd, keys

GEORGE
Dragon

GERTRUDE
Crown, lily, taper

GREGORY THE GREAT
Crozier, dove, tiara

H

HELENA
Cross

HUGH OF LINCOLN
Swan

I

IGNATIUS LOYOLA
Book, chasuble, Eucharist

ISIDORE
Bees, pen

J

JAMES THE GREATER
Key, pilgrim's staff, shell, sword

JEROME
Cardinal's hat, lion

JOHN THE BAPTIST
Head on platter, lamb, skin of animal

JOHN CHRYSOSTOM
Bees, dove, pen

JOHN THE EVANGELIST
Armor, chalice, eagle, kettle

JOHN OF GOD
Alms, crown of thorns, heart

JOSEPH
Carpenter's square, plane

JUSTIN MARTYR
Ax, sword

Continued on page 85

JULY

ANY OF THE SAINTS,
such as the 13th-century Italian theologian Bonaventure,
continue to enrich the life of the Christian Church through their
devotional writings. Bonaventure wrote:

> Thorns and cross and nails and lance,
> Wounds, our rich inheritance
> May these all our spirits fill,
> And with love's devotion thrill.

BONAVENTURE, *MEDITATION OF THE CROSS*

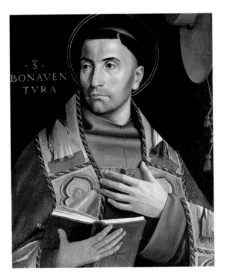

BONAVENTURE

✳ JULY ✳

THEODORIC
(DIED 533) ABBOT

T HEODORIC, or Thierry, born near Rheims, in France, founded a religious community at Mont d'Or. He was noted for the numerous people he helped to convert to the Christian faith.

AARON
OLD-TESTAMENT HIGH PRIEST

M oses' older brother, Aaron, is represented in art with a Jewish miter, a censer, and a rod in flower, reflecting the stories about him recorded in the Book of Exodus. Aaron was Moses' spokesman. The Lord said to Moses: "What about your brother, Aaron the Levite? …He will speak to the people for you, and it will be as if he were your mouth and as if you were God to him."

EXODUS 4:14-16.

THOMAS
(1ST CENTURY) APOSTLE

T HOMAS, one of Jesus' 12 apostles, is remembered for doubting Jesus' resurrection and for his subsequent expression of worship and faith at seeing the risen Jesus for himself. An ancient legend recounts how Thomas went to India as a missionary, where he was later martyred.

ELIZABETH
OF PORTUGAL
(1271–1336) QUEEN

A S wife of Denis, the King of Portugal, Elizabeth became a byword for her acts of piety and charity to the poor. She founded convents, hospitals, and shelters for prostitutes. After Denis died she became a Franciscan tertiary at a Poor Clare convent.

✳ JULY ✳

ANTHONY MARY ZACCARIA
(1502–1539) FOUNDER

Anthony was born in Cremona, Italy, and founded the Clerks Regular of St. Paul at Metan, who became known as the Barnabites, after St. Barnabas' Church, which was their center. This order was dedicated to bringing renewal to the spiritual life of the Church.

MARIA GORETTI
(1890–1902) MARTYR

Born in Corinaldo, in Italy, Maria was murdered by her father's partner, Alexander Serenelli, for resisting his advances. Maria was canonized for her purity by Pope Pius XII in 1950, in the presence of the totally repentant and reformed Serenelli.

RALPH
(DIED 866) BISHOP

Ralph, or Raoul, the son of Count Raoul of Chors, France, became abbot of several abbeys, before being appointed Bishop of Bourges. Ralph provided for the pastoral care of the monks in his monasteries through his writings.

THEOBALD
(1017–1066) HERMIT

Theobald was born into an aristocratic family at Provins in France. He became a hermit with a fellow ex-soldier in the Pettingen Forest in Luxembourg. They later moved to Salanigo in Italy. Theobald's holy life attracted many followers and he was canonized by Pope Alexander II in 1073.

✳ JULY ✳

VERONICA GIULIANI
(1660–1727)

*U*RSULA Giuliani, born at Mercatello in Italy, took the name Veronica when she joined the Capuchins at Città di Castello. After being a novice mistress for 34 years she became an abbess in 1716. She had vivid experiences of Christ's passion and even received the stigmata.

BENEDICT
(c. 480–550) ABBOT AND FOUNDER

A T Subiaco, in Italy, Benedict organized 12 monasteries before moving to Monte Cassino where he founded his arch-abbey. His rule for monks living in monasteries became known as "The Holy Rule" and earned Benedict the deserved title of the father of Western monasticism.

RUFINA
(DIED C. 257) MARTYR

R UFINA and her sister Secunda were engaged to be married when their fiancés denied the Christian faith, under Emperor Valerian's persecution of the Christians. Because Rufina and Secunda refused to deny Christ they were tortured and beheaded.

VERONICA
(1ST CENTURY) HEALER

A CCORDING to legend, when Christ fell under the weight of his cross, a lady wiped his face with a towel, on which an image of Christ's face became imprinted. This lady's name is derived from the Graeco-Latin *vera ikon* – true image. This incident was made popular by the Stations of the Cross.

✶ JULY ✶

SILAS
(1ST CENTURY) CHURCH LEADER

This leader of the Church at Jerusalem went with the apostle Paul on his second missionary journey, suffering imprisonment and beatings with him. Silas helped Peter write his first letter: "With the help of Silas, whom I regard as a faithful brother, I have written to you briefly."

1 PETER 5:12

CAMILLUS DE LELLIS
(1550–1614) FOUNDER

*D*ISCHARGED FROM the Venetian army with an incurable leg wound, Camillus founded a religious order called the Ministers of the Sick (the Camellians). In their Holy Ghost Hospital in Rome, and by traveling to plague-stricken parts of the world, the Camellians dedicated their lives to caring for the sick. Camillus is the patron of the sick and of nurses.

BONAVENTURE
(1221–1274) THEOLOGIAN

THIS FRANCISCAN, who became a cardinal and Bishop of Albano, centered his life on writing, teaching, and prayers on the cross of Christ. Although he was an eminent theologian, he revelled in commonplace jobs, saying, "One becomes holy only by doing common things well and being constantly faithful in small things."

✴ JULY ✴

MARY MAGDALEN POSTEL
(1756–1846) TEACHER

JULIA Frances Catherine was born at Barfleur in France, and took the name Mary Magdalen when she became superior of the Sisters of the Christian Schools of Mercy. She became a pioneer in the field of religious education.

CLEMENT OF OKHRIDA
(DIED 916) BISHOP AND MISSIONARY

CLEMENT became the first Slav bishop and founded a monastery at Okhrida in Bulgaria. His missionary work among the Bulgars met with such success that he is known as one of the Seven Apostles of Bulgaria.

FREDERICK OF UTRECHT
(DIED 838) BISHOP AND MARTYR

AS BISHOP of Utrecht, Frederick sent missionaries to the pagan parts of his diocese. He spoke out against the common practice of incestuous marriage, for which he incurred the wrath of Empress Judith, and on account of which he was stabbed to death in a church at Maastricht.

JUSTA AND RUFINA
(DIED C. 287) MARTYRS

THESE two sisters sold pottery in Seville in Spain, but refused to sell their goods for use in pagan ceremonies. They had their goods seized, were tortured and killed. Justa died on the rack, and Rufina was strangled.

✳ JULY ✳

MARGARET
(DATES UNKNOWN) MARTYR

Mₐᵣᵍₐᵣₑₜ, born at Antioch in Pisidia, also known as Marina, was driven out of her home when she embraced Christianity. The prefect Olybrius imprisoned Margaret for being a Christian when she refused to marry him, and she was then beheaded.

MARY MAGDALENE

LAWRENCE OF BRINDISI
(1559–1619) PREACHER

Cₐₑₛₐᵣₑ de Rossi, from Brindisi in the Kingdom of Naples, took the name Lawrence when he joined the Capuchins when he was 16. He studied Greek, Hebrew, and theology at the University of Padua, became a renowned preacher, and left nine volumes of sermons. Pope John XXIII made Lawrence a Doctor of the Church in 1959.

MARY MAGDALENE
(1ST CENTURY) REPENTANT SINNER

Jₑₛᵤₛ drove seven demons from Mary, who became his follower and stood at the foot of his cross. She was the first person to whom Jesus appeared after his resurrection.

✳ JULY ✳

BRIDGET of SWEDEN
(1303–1373) FOUNDRESS

*B*RIDGET founded a monastery at Vadstena in 1344 from which sprang the Order of the Most Holy Trinity (the Brigettines) and on account of which Bridget became the patron saint of Sweden. Her many visions and remarkable revelations are recorded in her book *Revelations*.

CHRISTINE
(DATES UNKNOWN) MARTYR

*S*T. Christine is venerated at Lake Bolsena in Latium and this tradition goes back to another St. Christine of Tyre. All that is known about St. Christine is that she suffered greatly for the Christian cause, before being martyred for her faith.

JAMES THE GREAT
(1ST CENTURY) APOSTLE

*J*AMES and his brother John were sons of Zebedee and fishermen from Galilee. James' symbol, the scallop shell, became the badge of medieval pilgrims.

✶ JULY ✶

ANNE
(1ST CENTURY BC)

CCORDING to the apocryphal *Protevangelium* of James, Anne, and Joachim (the parents of the Virgin Mary) were desolate about being childless. An angel told Anne that she would have a child and Anne responded by saying that she would dedicate the child to God. Anne is patron of pregnant women.

AURELIUS
AND NATALIA
(DIED C. 852) MARTYRS

URING the Moorish persecutions of Christians in Spain, Aurelius was brought up a Christian. He married Sabigotho, who took the name Natalia, or Natalie, when she became a Christian. With a friend, the monk George, Aurelius and Natalia were beheaded for their faith.

ANNE

JULY 28

SAMSON
(DIED C. 530) BISHOP

SAMSON was a wealthy doctor at Constantinople who founded a well-equipped hospital at St. Sophia for the poor, and became known as "the father of the poor" on account of his concern for their well-being.

JULY 29

MARTHA
(1ST CENTURY) VIRGIN

WITH her sister Mary and brother Lazarus, Martha often had Jesus as a guest in her home at Bethany, two miles from Jerusalem. When Martha complained to Jesus that Mary sat and listened to him while she was left to do all the work, Jesus said that Mary had chosen what was better.

JULY 30

JULITTA OF CAESAREA
(DIED C. 303) MARTYR

JULITTA, a wealthy widow, lived in Caesarea in Cappadocia. Her Christian convictions prevented her from offering sacrifices to Roman gods, so all her possessions were taken from her and she was burned to death.

JULY 31

IGNATIUS LOYOLA
(1491–1556) FOUNDER

IGNATIUS, author of *Spiritual Exercises*, took vows of poverty and chastity in 1534 with six divinity students, one of whom was Francis Xavier. They grew in number and became known as the Society of Jesus, or "Jesuits." Organized along strict military lines, they took Ignatius as their first general, and their missionary and teaching ministry flourished under his leadership.

AUGUST

GNATIUS LOYOLA

started with 10 Jesuits. By the time of his death the order had grown to over 1,000 members and included missionaries in many countries in Africa, Asia, and America.

THE PRAYER of the JESUITS

Teach us, good Lord, to serve you as you deserve;
to give, and not to count the cost;
to fight, and not to heed the wounds;
to toil, and not to seek for rest;
to labor, and not to ask for any reward,
save that of knowing that we do your will;
through Jesus Christ our Lord.

IGNATIUS LOYOLA

✳ AUGUST ✳

ALPHONSUS MARY DE' LIGUORI
(1696–1787) FOUNDER

ALPHONSUS Mary de' Liguori, born in Naples, founded the Congregation of the Most Holy Redeemer and became Bishop of Sant' Agata dei Goti, but later returned to the Redemptorist community. Throughout his preaching and writing he encouraged people to live out the teachings of Christ.

EUSEBIUS OF VERCELLI
(C. 283–371) BISHOP

BORN in Sardinia, Eusebius became bishop of Vercelli in Piedmont. He was the first Western bishop to unite the monastic and clerical life and the first bishop to live with his clergymen under the discipline of a rule, an example followed by Augustine.

NICODEMUS
(1ST CENTURY) RABBI

WHEN the leading Pharisee, Nicodemus, visited Jesus by night he was told that he needed to be born again. As a member of the Jewish ruling council, Nicodemus stood up for Jesus, saying that he should be listened to before being condemned. After Jesus' death Nicodemus helped Joseph of Arimathea place Jesus' body in the tomb.

JOHN VIANNEY
(1786–1859) TEACHER

OFTEN called "the Curé d'Ars," John was born near Lyons and became parish priest of the neighboring village of Ars. He spent the rest of his life there. His work among orphans, the poor, and young girls became legendary far beyond France. He often spent 16–18 hours in the confessional, giving spiritual counsel. He is the patron of parish clergy.

✳ AUGUST ✳

AFRA
(DIED 304) MARTYR

DURING Emperor Diocletian's persecution of the Christians, Afra refused to offer sacrifices to the pagan gods and so was burned to death in Cologne for her Christian faith.

JUSTUS AND PASTOR
(DIED C. 304) MARTYRS

PRUDENTIUS ranks the brothers Justus and Pastor among the most celebrated Spanish martyrs. Justus, aged 13, and Pastor, aged 9, fell victim to Emperor Diocletian's persecution and boldly declared their Christian faith when interrogated, for which they were scourged and beheaded at Alcala.

CAJETAN
(1480–1547) FOUNDER

DECLINING various prestigious posts that were offered to him in Rome, Cajetan joined the Oratory of St. Jerome, caring for the poor and sick, especially the incurable. With Peter Caraffa (who later became Pope Paul IV), Cajetan founded the congregation of clerks, who were noted for their complete trust in God's providence. They are known as Theatines, after Theate, where Caraffa was bishop.

MARY MACKILLOP
(1842–1909) FOUNDRESS

BORN in Australia, Mary MacKillop founded the Sisters of St. Joseph of the Sacred Heart at Penola, South Australia, in 1866. Because of diocesan rivalry, Mother Mary was excommunicated from the Church in 1871. However, Pope Pius overruled other authorities in this matter and reinstated Mother Mary, so that she continued as head of the order she had founded.

✳ AUGUST ✳

EMYGDIUS
(DIED 304) MARTYR

*O*N a visit to Rome, Emygdius destroyed an idol in a pagan temple and was forced out of the city. He was so successful for the cause of Christ in evangelizing the Italian region of Ascoli Piceno that he was arrested during the Diocletian persecution and beheaded.

LAURENCE OF ROME
(DIED 258) MARTYR

L AURENCE was distraught when Pope Sixtus II, to whom he was deacon, was martyred. He believed that he, too, would shortly be martyred, so he sold all the possessions of the church that he could find and gave the money to the poor. When the Roman prefect heard about this, he demanded that all the treasures of the church be presented to the emperor. Laurence then collected the poor, crippled, blind, and all the orphans he could and presented them to the prefect, saying, "Here are the treasures of the Church."

CLARE OF ASSISI
(1194–1253) FOUNDER

F RANCIS of Assisi encouraged Clare Offreduccio to become a nun. She went on to found her own religious community, which embraced strict poverty, and her nuns became known as the "Poor Clares." While they remained poor themselves, not wearing anything on their feet and never eating meat, they spent their lives in caring for the poor.

EUPLIUS
(DIED 304) MARTYR

E UPLIUS, a deacon from Catania, in Sicily, was caught in possession of a copy of the four Gospels. Under Emperor Diocletian's persecution of the Christians he was arrested and then beheaded.

✳ AUGUST ✳

PONTIAN
(DIED C. 236) MARTYR

*P*ONTIAN became Pope in 232, but due to Emperor Maximinus' persecution of the Christians was forced into exile to Sardinia. One tradition claims that he was beaten to death there.

MAXIMILIAN KOLBE
(1894-1941) MARTYR

THIS Polish priest was one of many who made the ultimate Christian sacrifice during World War II. As prisoner 16670 in the Auschwitz death camp, Maximilian asked that he should be executed in place of another prisoner, Franciszek Gajowniczek, who pleaded that he should be spared for his wife and children's sake. After Kolbe received his lethal injection of carbolic acid, the patriot Szczepanski commented, "By this one act the world of violence was lost." Pope Paul VI beatified Kolbe in 1971.

MARY AT THE FOOT OF THE CROSS

THE blessed Virgin Mary watched Jesus being put to death by the most cruel means devised by man – crucifixion. As Jesus died he showed his great love for his mother. "When Jesus saw his mother there, and the disciple whom he loved standing near by, he said to his mother, 'Dear woman, here is your son,' and to the disciple, 'Here is your mother.' From that time on, this disciple took her into his home."

JOHN 19: 26–27

STEPHEN OF HUNGARY
(975–1038) KING

STEPHEN became the first King of Hungary and then set about making his country a Christian one. He established sees, built churches, and arranged for tithes to be paid for their support. The most famous abbey that he founded is the Benedictine abbey of Pannonhalma.

✳ AUGUST ✳

HYACINTH
(1185–1257) TEACHER

THE Apostle of Poland, as Hyacinth became known, received his Dominican habit from the hands of St. Dominic himself. He then spent his life teaching and evangelizing in many countries, including Lithuania, Prussia, Norway, and even Tibet, as well as Poland.

STANISLAUS KOSTKA
(1550–1568)

BORN in Poland, at the age of 17 Stanislaus walked 350 miles to Dillengen, in Germany, where he was accepted as a Jesuit by Francis Borgia, the father-general of the Society of Jesus. He experienced many religious visions.

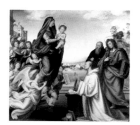

APPARITION OF THE
VIRGIN TO ST. BERNARD

JOHN EUDES
(1601–1680) FOUNDER

EUDES worked among the victims of the plagues that hit Normandy from 1625 to 1631, often being exposed to the plague himself. During the next 10 years he became a traveling preacher.

BERNARD OF CLAIRVAUX
(1090–1153) ABBOT

BERNARD was asked to leave the over-crowded monastery of Côteaux with 12 monks and form a daughter-monastery. Bernard chose a site in the Champagne region of France called the "Valley of Wormwood," which he renamed "Clairvaux," the "Valley of Light." He became one of the greatest monastic leaders of all time, and greatly expanded the Cistercian order.

* AUGUST *

PIUS X
(1835–1914) POPE

IUSEPPE Melchior Sarto, from Riese in Italy, was elected Pope on August 4, 1903. He encouraged frequent reception of Holy Communion, especially by children, reformed the papal court, and ordered a revision of the Vulgate translation of the Bible, as well as a revision of the breviary and the psalter.

MARY'S ONE COMMAND

MARY was present at the wedding at Cana where Jesus changed the water into wine. Mary's one command, given to the servants, is recorded by John: "Do whatever he [Jesus] says."

JOHN 2:5

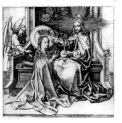

ROSE OF LIMA
(1586–1617) RECLUSE

ISABEL de Santa Maria de Flores, of Lima in Peru, became the first American-born person to be canonized (1671) and today she is known as the patron saint of South America. She lived as a recluse in a shack and inspired many by her simple, pious life and her extraordinary visions and spiritual gifts. Her garden became the spiritual focus of Lima.

BARTHOLOMEW
(1ST CENTURY) APOSTLE

XCEPT for his name appearing in the list of all of Jesus' disciples, nothing is known about Bartholomew from the Gospels. However, Nathanael is probably the same person as Bartholomew. When Nathanael met Jesus, Jesus said of him, "Here is a true Israelite, in whom there is nothing false."

JOHN 1:43–51

AUGUST 25

LOUIS IX
(1214–1270) KING

*L*OUIS IX of France, born at Poissy, encouraged religious and educational establishments. He had the Sainte Chapelle in Paris rebuilt and supported the founding of the Sorbonne. He ruled France for 44 years and was canonized by Pope Boniface in 1297.

AUGUST 26

CAESARIUS OF ARLES
(470–543) BISHOP

*C*AESARIUS, born at Châlons, in France, became Bishop of Arles. He insisted that the Divine Office should be sung every day in every church in Arles. He also founded a convent there, where he remained bishop for 40 years, noted for his charitable good deeds.

MONICA
(c 331–387) WIDOW

*M*ONICA, Augustine's mother, prayed for her wayward son for the four years he was living in Carthage with his mistress. Her prayers were answered, just as they had been for her non-Christian husband before his death, and Augustine was baptized on Easter Day in 387. Monica, patroness of married women, is seen as a model Christian mother.

AUGUSTINE
(354–430)
BISHOP AND THEOLOGIAN

*A*UGUSTINE not only dominated the medieval Church in the West but is still held in great esteem by Catholic and Protestant theologians alike. In his writings, of over 50 volumes – which are his gift to the Church – he developed the idea "believe in order that you may understand." His *Confessions* are the oldest Christian spiritual autobiography in existence.

✳ AUGUST ✳

BEHEADING OF JOHN THE BAPTIST
(1ST CENTURY) MARTYR

*J*OHN the Baptist spoke out fearlessly against Herod Antipas' marriage to his brother Philip's wife, Herodias. For this he was imprisoned. John met his death on Herod's birthday, when Herodias told her daughter to say to Herod: *"Give me here on a platter the head of John the Baptist."*

MATTHEW 14:8

FELIX
(DIED C. 304) MARTYR

*F*ELIX, a priest in Rome during the Diocletian persecution, was tortured and martyred for his Christian faith. On the way to his execution a Christian was so impressed by Felix's faith that he declared his own Christian faith. He, too, was martyred with Felix. As his name was not known, he was called Adauctus, "the added one."

AIDAN
(DIED 651) BISHOP

*A*IDAN, a monk on Iona, evangelized northern England at the request of King Oswald of Northumbria. Aidan was made Bishop and Abbot of Lindisfarne, where he became famous for his Bible teaching and preaching and his concern for the poor. He is represented in art by a stag because of a story in which he made a stag disappear, thus preserving it in a hunt.

The Saints and Their Symbols in Art

L

LAWRENCE
GRIDIRON

LUCY
EYES

LUKE
BOOK, PALETTE

M

MARK
BOOK, LION

MARY MAGDALEN
ALABASTER BOX OF OINTMENT

MATTHEW
MAN WITH WINGS

MONICA
TEARS

N

NICHOLAS
THREE PURSES, THREE BALLS

P

PATRICK
SHAMROCK

PAUL
SCROLL, SWORD

PETER
KEYS

PHILIP
LOAVES

R

ROSE OF LIMA
ANCHOR, CITY

S

SEBASTIAN
ARROWS

STEPHEN
STONES

T

TERESA OF AVILA
ROSE

THOMAS
LANCE

THOMAS À BECKET
SWORD

SYMBOLS USED WITH WHOLE CLASSES OF SAINTS

BISHOPS
PASTORAL STAFF

FOUNDERS OF CHURCHES
CHURCH BUILDING AND MONASTERIES (SOMETIMES HELD)

LEARNED PEOPLE
BOOK AND PEN

MARTYRS
PALM, SWORD

POPE
TIARA

ROYALTY
CROWN

SEPTEMBER

T HAS RECENTLY
been estimated that more Christians have been put to death on
account of their faith in Christ in the 20th century than in all
the other centuries put together. Many regard Dietrich Bonhoeffer's execution
as a martyrdom. The prison doctor wrote:

> Through the half-open door in one of the huts I saw Pastor
> Bonhoeffer, before taking off his prison garb, kneeling on the floor,
> praying fervently to his God. I was deeply moved by the way this
> lovable man was praying, so devoutly and so sure that God heard
> him. At the place of execution he again said a short prayer and then
> climbed the steps to the gallows, brave and
> composed. His death ensued after a few
> seconds. In the almost 50 years I worked
> as a doctor, I hardly ever saw a man die
> so submissive to the will of God.

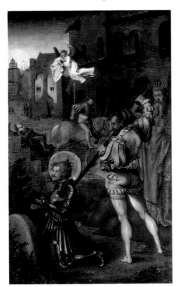

MARTYRDOM OF ST. MAURICE

✳ SEPTEMBER ✳

GILES
(c. 712) ABBOT

*G*ILES is believed to have been a hermit near Arles, in France, where he founded a monastery and became its abbot. His spiritual wisdom became so well known that even Charlemagne sought his advice. He is the patron of beggars and cripples. One church in London was aptly named St. Giles Cripplegate after him.

JUSTUS OF LYONS
(DIED C. 390) BISHOP

*A*FTER Justus became Bishop of Lyons, a man who had sought sanctuary in his church was killed, despite the assurances of his safety that Justus had given him. So Justus secretly left Lyons and joined a monastery in Egypt with the deacon, Viator. Even though his identity became known, Justus never returned to Lyons, but died at the monastery.

GREGORY THE GREAT
(c. 540–604) POPE

*C*ALLING himself "the Servant of the Servants of God," Gregory is remembered for all he achieved in the 14 years of his pontificate. He came across some English slaves for sale in Rome and when he asked who they were, was told, "They are Angles;" to which he replied, "They are not Angles, but angels!" He sent Augustine to England and so became the first Pope to send missionaries there.

BONIFACE I
(DIED 422) POPE

*B*ONIFACE became Pope in 418. He was already an old man and had to cope with Eulalius, who had also been elected Pope by a group of dissidents the day before Boniface became Pope. Boniface became so opposed to the heresy of Pelagius that Augustine dedicated a number of his writings against Pelagianism to Boniface.

SEPTEMBER

LAWRENCE GIUSTINIANI
(1381–1455) BISHOP

ORN in Venice, Giustiniani went to Alga island, near Venice, where he joined a community called the Canons Regular of San Giorgio in Alga. He later became their general. He was noted for his extreme austerity and could often be seen begging in Venice. He was also known for his spiritual writings, which were both simple and profound, especially *The Degree of Perfection*.

DONATIAN
(DIED C. 484) MARTYR

HEN Hunneric, the King of the Vandals, closed all the churches in North Africa, Donatian and his friends were tortured, driven into the desert, and left to die of exposure.

CLOUD
(C. 520–C. 560) HERMIT

RINCE Cloud, Clodoalus, Clodoald, or Clodulf, became a monk, even though he had a legitimate claim to the Frankish throne. The place where he died was called Saint-Cloud after him and is now a commune of Versailles.

BIRTH OF THE VIRGIN MARY
(1ST CENTURY B.C.)

HE traditional names of the parents of Mary are Anne and Joachim. They are always depicted in art as being pious and God-fearing people. Tradition states that in gratitude to God for the birth of Mary, Anne promised to dedicate the child to the Temple, and Joachim held a birthday party with "the priests and scribes and the assembly of the elders and the whole people of Israel."

BOOK OF JAMES 6:2

SEPTEMBER ✳

PETER CLAVER

(1581–1654) TEACHER AND MISSIONARY

*C*LAVER, born near Barcelona at Verdu, became a Jesuit at the age of 20. He went as a missionary to New Granada and alleviated the terrible suffering of the slaves who arrived from West Africa caged like animals. Claver gave them food and medicine as well as spiritual comfort. He is said to have cared for and baptized 300,000 slaves.

NICHOLAS OF TOLENTINO

(1245–1305) TEACHER

*B*ORN in Fermo, Nicholas became a hermit with the Augustinian order. After his ordination he said that he would preach every day to the people, which he did at Cingoli and then at Tolentino for 30 years.

PROTUS AND HYACINTH

(3RD CENTURY) MARTYRS

*H*YACINTH'S remains were discovered just outside Rome, in the cemetery of St. Hermes' Basilica, on the Salernian Way, in 1845. Protus' tomb was also found near this site. The brothers were beheaded for their Christian faith.

GUY OF ANDERLECHT

(DIED C. 1012) PILGRIM

*B*ORN near Brussels, Guy spent his life in caring for the poor. After making a pilgrimage to Rome and Jerusalem on foot, he died in Anderlecht hospital. On his grave he was given the name of "the poor man of Anderlecht."

✳ SEPTEMBER ✳

JOHN CHRYSOSTOM
(350–407) BISHOP AND THEOLOGIAN

HAVING lived as an ascetic scholar and a hermit in the mountains, Chrysostom became Bishop of Constantinople, where his eloquence later earned him the title "Chrysostomos," or "Golden-mouthed." He ranks among the greatest preachers in the history of the Church.

THE GLORIOUS CROSS

ST. Paul linked the cross of Christ and glory in his writings. He wrote about the rulers of this age crucifying "the Lord of glory" (1 Corinthians 2:8), and he boasted that he wanted to glory in the cross of Jesus.

CATHERINE OF GENOA
(1447–1510) CARER

BORN in Genoa, Catherine devoted most of her life to serving the sick in Pammetone hospital. She lived there with her husband, narrowly escaping death herself as she cared for so many people who had the plague, which killed three-quarters of the population.

CYPRIAN
(c. 200–258) BISHOP AND MARTYR

CYPRIAN became Bishop of Carthage in 248 and was martyred 10 years later. He had to cope with the aftermath of the Decian persecution when some Christians, who had denied Christ under threat of execution, later wanted to return to the Christian community.

SEPTEMBER ✳

LAMBERT OF MAASTRICHT
(635–705) MARTYR

LAMBERT became bishop of his home-town, Maastricht, before being driven out by the tyrant Ebroin. Lambert then became a monk at Stavelot for seven years. After Ebroin's death, Lambert was reinstated. But Lambert denounced the adultery of Ebroin's successor, Pepin, and for this he was murdered at Liège.

JOSEPH OF COPERTINO
(1603–1663) VISIONARY

JOSEPH Desa, born near Brindisi in Italy, became a friar at the Conventual Franciscan house at La Grotella. He experienced outstanding ecstasies and raptures and so was excluded from a great deal of the daily work of the order. He died in seclusion at Osimo.

JANUARIUS
(DIED C. 305) MARTYR

JANUARIUS, Bishop of Benevento, visited some of his Christian friends who had been imprisoned under Emperor Diocletian's persecution. Benevento was arrested and he and his friends were thrown to the wild beasts. The animals did not harm them, so they were all beheaded.

DOMINIC DE GUZMAN
(1170–1221) FOUNDER

DOMINIC founded an order of friars known as the friar preachers, whom he sent everywhere to preach and teach. This Dominican order spread throughout the world as a result of the compassion of its founder for all kinds of human suffering.

✳ SEPTEMBER ✳

MATTHEW
(1ST CENTURY) APOSTLE

ATTHEW, also known as Levi, was called from being a tax collector to follow Jesus. He left everything and held a reception in his home for Jesus, many "tax collectors" and "sinners." Matthew is the traditional author of the first Gospel.

MAURICE
(DIED C. 287) MARTYR

MAURICE and an entire legion of up to 6,000 men were martyred by Maximian, when they refused to offer sacrifices to the gods, which was supposed to guarantee them success in battle. Maurice encouraged the other legionnaires to be faithful in their stand.

ADAMNAN
(C. 624–704) ABBOT

A DAMNAN became the ninth abbot on the island of Iona, in Scotland. His biography of St. Columba became one of the most important biographies of the Middle Ages. He got laws passed preventing women from going to war, and children from being slaughtered during a war. These laws became known as Adamnan's Law.

✳ SEPTEMBER ✳

SEPTEMBER 24

GERARD SAGREDO
(DIED 1046) BISHOP AND MARTYR

GERARD, born in Venice, became a Benedictine monk, and while on a pilgrimage to Jerusalem was persuaded by King Stephen of Hungary to become the tutor of his son and work among the Magyars. He became Bishop of Csanad, but as soon as Stephen died, Gerard was murdered at Buda as a result of a pagan backlash against Stephen's Christian reforms. He is "the Apostle of Hungary."

SEPTEMBER 25

NICHOLAS OF FLUE
(1417–1487) HERMIT

BORN in Switzerland, at Flüeli, Nicholas became a hermit at the age of 50, with the blessing of his 10 children and wife. During the last 19 years of his life he became well known for his holiness and wisdom, and many people visited him to seek his advice.

SEPTEMBER 26

COSMAS AND DAMIAN
(DIED 303) MARTYRS

COSMAS and Damian, twins from Arabia, practiced as doctors, often giving their services without charge to poor people. Because they were known to be faithful Christians, the governor of Cilicia, Lysis, had them arrested, tortured, and beheaded.

SEPTEMBER

VINCENT DE PAUL
(c. 1580–1660) CONFESSOR

In 1625 Vincent founded the Congregation of the Mission (known as the Vicentians and Lazarites). This missionary work among peasants soon spread throughout France. To a member of this mission, in 1633, he wrote:

"I have been reading about the simple, normal way of life that our Lord willed to live while he was on earth ... Although he was the uncreated Wisdom of the Eternal Father, yet it was his will to preach his doctrine in a much more commonplace and ordinary style than his apostles."

WENCESLAUS
(c. 903–929) MARTYR

Wenceslaus, or Vaclav, born near Prague, became ruler of Bohemia in 922 and supported Christianity whenever possible. His brother Boleslaus invited him to a religious festival at Boleslayvia, and as he traveled there Wenceslaus was murdered. Wenceslaus was immediately venerated as a martyr and continues to be the patron of Bohemia.

MICHAEL
AND ALL ANGELS

Michaelmas Day recalls how Michael and his angels defeated the devil.

"And there was war in heaven. Michael and his angels fought against the dragon, and the dragon and his angels fought back. But he was not strong enough, and they lost their place in heaven. The great dragon was hurled down – that ancient serpent called the devil, or Satan, who leads the whole world astray."

REVELATION 12:7-9

SEPTEMBER ✳

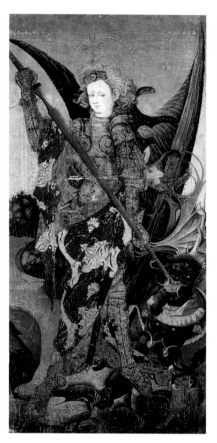

ST. MICHAEL

JEROME
(c. 342–420) CONFESSOR

A NOTED preacher, who was not afraid to promote the idea of asceticism to a congregation of wealthy Christians, Jerome became the most respected and learned biblical scholar of his day. His greatest achievement was his Latin version of the Bible, known as the Vulgate (Latin *vulgatus*, "made known to the people"), which became the standard version of the Bible in Europe for over a thousand years.

OCTOBER

FRANCIS OF ASSISI

went on a pilgrimage to Rome, where he was moved to the depths of his being by the sight of all the beggars outside St. Peter's. For one day he exchanged his own clothes for those of one of the beggars and spent the day begging. Coming from a very well-off family, Francis was deeply affected by this experience of being penniless. When he returned home, his father would have nothing to do with him, and Francis spent his days looking after lepers.

One day, while Francis was worshiping God in St. Damiano Church, he heard these words of Jesus being read from St. Matthew 10:7-19:

> Heal the sick, cleanse the lepers, raise the dead, cast out devils: freely ye have received, freely give. Provide neither gold, nor silver, nor brass in your purses; Nor scrip for your journey, neither two coats, neither shoes, nor yet staves.

Francis threw away his staff, removed his shoes and went around barefoot. He put on a long, black-hooded cloak with a simple cord belt and set out to preach the Gospel.

✳ OCTOBER ✳

THÉRÈSE of LISIEUX
(1873–1897) NUN

*T*HÉRÈSE entered a Carmelite convent at 15, but ill health prevented her from becoming a missionary with other sisters of her order in China. Affectionately called "The Little Flower" she recounted her moving story and her fight against tuberculosis, from which she died aged 24, in her spiritual autobiography *Story of a Soul*, which her superior asked her to record.

THE GUARDIAN ANGELS

The teaching of Jesus encourages us to believe that we each have our own guardian angel. He once said, "See that you do not look down on one of these little ones. For I tell you that their angels in heaven always see the face of my Father in heaven."

MATTHEW 18:10

GERARD OF BROGNE
(c. 895–959) ABBOT

ERARD built a monastery on his own estate at Brogne, became its abbot, and lived a life of such exemplary discipline that he was asked to reform the abbey of Saint-Ghislain. Then Gerard was invited to reform monasteries in Flanders and Normandy, where his strict approach was not always appreciated.

FRANCIS of ASSISI
(1181–1226) FOUNDER

ST. FRANCIS of Assisi was born into a wealthy family but gave up his worldly privileges to lead a simple life devoted to the poor and to prayer. He is remembered for his deep humility, love of nature, great generosity, and quiet faith.

✴ OCTOBER ✴

FLORA OF BEAULIEU
(1309–1347) NUN

FLORA, who was born at Auvergne in France, joined the nuns of the Order of St. John of Jerusalem, known as the Hospitalers, at Beaulieu, in 1324. She became well known for long fasts and for experiencing religious visions.

JUSTINA OF PADUA
(DATES NOT KNOWN) MARTYR

JUSTINA was supposed to have been baptized by St. Prosdocimus, who was one of St. Peter's disciples and possibly the first Bishop of Padua. Little is known for certain about Justina, except that she was martyred for her faith.

BRUNO
(C. 1030–1101) FOUNDER

WITH six companions, Bruno built an oratory in the region of the Alps known as La Grande Chartreuse. Thus the Carthusian Order was founded, based on a life of manual work, poverty, prayer, and transcribing manuscripts. His name was added to the Roman calendar in 1623, but he was not canonized, since the Carthusians are against public honors.

SIMEON
(1ST CENTURY) PROPHET

THIS devout Jew lived in Jerusalem and had been told by the Holy Spirit that he would see the Lord Christ before his death. As Mary and Joseph brought the baby Jesus into the temple, Simeon took him in his arms, and said the song of praise. Today we call this the Nunc Dimittis: "Lord, now let your servant depart in peace."

✳ OCTOBER ✳

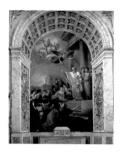

DENIS
(DIED C. 258) MARTYR

DENIS became the first Bishop of Paris, having been sent to Gaul from Italy, along with 250 missionaries. His evangelization was so successful that he and his assistants, St. Eleutherius and St. Rusticus, were arrested, imprisoned, and beheaded.

GISLENUS
(DIED C. 680) FOUNDER

GISLENUS, or Ghislain, founded a monastery at Saint-Ghislain, near Mons, and became its first abbot, after he had lived as a hermit at Hainault. He also encouraged the founding of two convents, at Castilocus and Mauberge.

TARACUS, PROBUS, AND ANDRONICUS
(DIED 304) MARTYRS

TARACUS, a retired Roman army officer, along with Andronicus, a young man from Ephesus, and Probus, a Roman citizen from Pamphilia, were arrested and endured three interrogations because of Emperor Diocletian's persecution of the Christians. They were thrown to the wild beasts in an arena near Tarsus, but since they were unharmed by the animals they were killed by the gladiator's sword.

EDWIN
(C. 585–633) KING

EDWIN became the most powerful king in England, and during his reign Christianity was established in Northumbria. He appointed Paulinus Bishop of York and greatly encouraged Paulinus and Ethelburga in their missionary work in England.

✳ OCTOBER ✳

EDWARD THE CONFESSOR
(1003–1066) KING

THE belief that Edward, King of England from 1042, was a saint grew out of his religious devotion, generosity to the poor, and supposed possession of the "divine touch of kings," which cured scrofula, a general description for many diseases of the time. Buried in Westminster Abbey, he is the only English saint whose bodily remains still rest in their medieval shrine.

CALLISTUS I
(DIED C. 222) POPE AND MARTYR

CALLISTUS, after serving a sentence of hard labor in the Sardinian quarries, was appointed keeper of the Christian cemetery on the Appian Way in Rome. In 217 he was elected Bishop of Rome and was often opposed for his generous treatment of sinners. He was probably killed by a riot and has always been venerated as a martyr.

TERESA OF AVILA
(1515–1582) FOUNDRESS

TERESA de Cepeda y Ahumada, after 25 years as a nun, became well known in her native Spain when she founded the deeply spiritual and disciplined Order of Discalced (literally, shoeless or barefooted) Carmelites. Working with her contemporary John of the Cross, she faced bitter opposition from her superiors in founding convents and caring for nuns scattered across Spain.

GERARD MAJELLA
(1726–1755) SPIRITUAL ADVISER

GERARD, born in Muro, Lucania, became a brother with the Redemptorists, among whom he was well known for his great love for the poor and his zeal in winning souls for God. He was endowed with the gifts of healing, understanding mysteries, and prophecy.

OCTOBER 17

IGNATIUS OF ANTIOCH
(DIED C. 107) BISHOP AND MARTYR

IGNATIUS, often called Theophoros ("God-bearer"), is known for the seven letters he wrote that throw light on Christian belief and practice in the century following Christ's death. Ignatius was most probably thrown to the lions in the Colosseum in Rome.

OCTOBER 18

LUKE
(1ST CENTURY) EVANGELIST

THE writer of the third Gospel and of the Acts of the Apostles was a doctor by profession. He accompanied the apostle Paul on his missionary journeys. 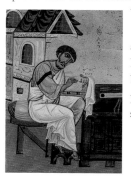 The tradition that he was an artist may have been based on his picturesque style of writing.

OCTOBER 19

PAUL OF THE CROSS
(1694–1775) FOUNDER

PAUL Francis Danei, born at Ovada, Italy, was told in a vivid vision to found a religious order devoted to the preaching of the Passion of Christ. By 1741, with the constant help of his brother John, Paul founded the Barefooted Clerks of the Holy Cross and Passion, known as the Passionates, and the movement then spread throughout Italy.

OCTOBER 20

ADELINA
(DIED 1125) ABBESS

ADELINA, granddaughter of William the Conqueror, became abbess of the Benedictine convent of La Blance. Her sister, Vitalis, originally founded this convent at Moriton in Normandy.

✳ OCTOBER ✳

HILARION
(c. 291–c. 371) HERMIT

ILARION gave all his inherited wealth to the poor and then spent the rest of his life as a hermit. He went to the desert where St Antony had been, to Gaza, to Majuma in Palestine, to Sicily and then to Dalmatia. In each place many were attracted to his hermitage because of his holy way of life.

NUNILO AND ALODIA
(DIED 851) MARTYRS

Two sisters, Nunilo and Alodia, born at Adahuesca in Spain, had a Muslim father and a Christian mother. Their mother brought them up as Christians, but when their father died, their new stepfather, another Muslim, persecuted and imprisoned them. They were beheaded at Huesca.

JOHN OF CAPISTRANO
(1386–1456) PREACHER

AT the age of 30, John became a Franciscan friar. He spent the next 30 years of his life as an itinerant preacher, traveling throughout the length and breadth of Italy.

ANTHONY CLARET
(1804–1870) BISHOP AND FOUNDER

IN 1849 Anthony founded the order now known as the Claretian Fathers to hold parish missions and retreats in Catalonia, Spain. Also in 1849, Queen Isabella II appointed Anthony as Archbishop of Santiago, Cuba. Anthony implemented numerous overdue reforms in this diocese, often narrowly escaping attempts on his life.

✳ OCTOBER ✳

OCTOBER 25

CRISPIN
AND CRISPINIAN
(DIED C. 285) MARTYRS

*T*wo brothers, Crispin and Crispinian, patron saints of shoemakers, evangelized in the area around Soissons, in France, by day and worked as shoemakers by night. They were tortured and beheaded at Soissons by Rictiovarus, an imperial magistrate, who loathed Christians.

OCTOBER 26

ALFRED THE GREAT
(849–899) KING

*A*LFRED, King of Wessex, is remembered as the model for Christian kingship. He supported education, especially of the clergy, and himself translated into English a number of important Christian books, such as the *Dialogues* of Gregory the Great.

OCTOBER 27

FRUMENTIUS
(DIED C. 380) BISHOP

RUMENTIUS was secretary to the King of Ethiopia. On the king's death, the queen asked them to stay on and evangelize her country. Eventually Frumentius became the Bishop of Ethiopia and "apostolic signs accompanied his ministry, and a great number of heathen were won to the faith."

OCTOBER 28

SIMON
(1ST CENTURY) APOSTLE

*S*IMON, not to be confused with Simon Peter, was one of Jesus' 12 apostles. He is known as Simon the Zealot, since he was probably a member of a Jewish revolutionary group who were dedicated to driving the Romans out of Israel.

✳ OCTOBER ✳

THEODORE
(DIED C. 575) ABBOT

THEODORE, or Theuderius, founded several monasteries, including one near Vienne. He was so eager to be a hermit that he lived as a walled-up recluse in the Church of St. Laurence, Vienne, for the last 12 years of his life.

SERAPION
(DIED C. 211) BISHOP

As an early Bishop of Antioch, Serapion set his face against the heresy of the moment – Docetism (a doctrine that claimed that Christ only appeared to be God, but was not really God). He also did not allow the apocryphal Gospel of Peter to be read at Rhossos Church.

QUENTIN
(DIED 287) MARTYR

QUENTIN is an example of a bold preacher of the Christian gospel becoming so successful that he was martyred. Quentin's ministry centered around Amiens in France, where the local prefect arrested him, tortured and then beheaded him.

The Saints as Patrons
of Countries and Places

AMERICAS
ROSE OF LIMA

ARGENTINA
OUR LADY OF LUJAN

ARMENIA
**GREGORY THE
ILLUMINATOR;
BARTHOLOMEW**

ASIA MINOR
JOHN THE EVANGELIST

ASSISI
FRANCIS OF ASSISI

AUSTRALIA
**OUR LADY HELP OF
CHRISTIANS**

AUSTRIA
SEVERINO

AVIGNON
AGRICOLA OF AVIGNON

BAVARIA
SEBALD

BELGIUM
JOSEPH

BOHEMIA
WENCESLAUS

BRAZIL
ANTHONY OF PADUA

BRITTANY
IVO

CANADA
ANNE; JOSEPH

CHILE
JAMES

CHINA
JOSEPH

COLUMBIA
**LOUIS BERTRAND; PETER
CLAVER**

CRETE
TITUS

CYPRUS
BARNABAS

CZECH REPUBLIC
WENCESLAUS

DENMARK
CANUTE

EAST INDIES
FRANCIS XAVIER

ENGLAND
**AUGUSTINE OF
CANTERBURY; GEORGE;
GREGORY THE GREAT**

ETHIOPIA
FRUMENTIUS

EUROPE
**CYRIL AND METHODIUS
(CO-PATRONS)**

FINLAND
HENRY OF UPPSALA

FRANCE
**JOAN OF ARC; MARTIN OF
TOURS; THÉRÈSE OF
LISIEUX**

GERMANY
BONIFACE

GREECE
**ANDREW; NICHOLAS OF
MYRA**

Continued on page 123

NOVEMBER

HE FIRST MARTYRS *of Rome are recorded in the old Roman Martyrology, which states that:*

At Rome, the birthday is celebrated of very many holy martyrs, who under the Emperor Nero were falsely charged with the burning of the city and by him were ordered to be slain by various kinds of cruel deaths; some were covered with the skin of wild beasts, and cast to the dogs to be torn asunder; others were crucified, and when daylight failed were used as torches to illuminate the night. All these were disciples of the apostles and the first fruits of the martyrs whom the Holy Roman Church sent to their Lord before the apostles' death.

✳ NOVEMBER ✳

BENIGNUS OF DIJON
(2ND OR 3RD CENTURY) MARTYR

*T*HERE is only poor evidence to support the tradition that Benignus was a disciple of Polycarp who was martyred at Dijon during Marcus Aurelius' reign. However, Benignus has been venerated in Dijon since the sixth century.

VICTORINUS
(DIED C. 304) BISHOP AND MARTYR

*V*ICTORINUS was one of the earliest theologians in the Western Church to write commentaries on books of the Bible. As Bishop of Pettua he fought against many heresies, before being martyred.

HUBERT
(DIED 727) BISHOP

*H*UBERT is supposed to have been converted while hunting on Good Friday when he came across a stag with a crucifix between its antlers. Hubert became Bishop of Tongres-Maestricht.

CHARLES BORROMEO
(1538–1584) ARCHBISHOP

*C*HARLES Borromeo was appointed Archbishop of Milan by his uncle, Pope Pius IV, three years before he became a priest, let alone a bishop. However, he was one of the ablest and most compassionate Christian leaders of his age. He established theological colleges to train future clergy, encouraged children to be taught the Christian faith, and increased the help given to the poor.

ELIZABETH
AND ZACHARIAH
(1ST CENTURY)

*E*lizabeth and Zachariah the priest were the parents of John the Baptist. Elizabeth greeted her cousin Mary, the mother of Jesus, when she visited her with the words, "Blessed are you among women, and blessed is the child you will bear!"

LUKE 1:42

NOVEMBER

LEONARD OF NOBLAC
(DIED C. 559) ABBOT

KING Clovis I believed that Leonard's prayers had brought his wife safely through a difficult labor and rewarded the hermit of Limoges with all the land he could ride around, on a donkey, in one day. Leonard founded Noblac monastery on this site.

WILLIBRORD
(658–739) ARCHBISHOP

BORN in Northumbria in northeast England, Willibrord became Archbishop of the Frisians, with his base in Utrecht. Later Willibrord established a second missionary center at the monastery of Echternach. Alcuin wrote of Willibrord, "His charity was manifest in his unremitting labor for Christ's name's sake."

WILLEHAD
(DIED C. 789) BISHOP

NORTHUMBRIAN monk Willehad went to evangelize the Frisians and, later, the Saxons. He established *chorepiscopi* ("country bishops") in Western Europe to assist with the work of evangelism. When he died he was Bishop of Bremen.

NEKTARIOS OF PENTAPOLIS
(1846–1920) BISHOP

NEKTARIOS became Bishop of Alexandria but took refuge in Egypt because of those who opposed his appointment. He became director of Rizareion theological school in Athens. To help an ill cleaner, Nektarios cleaned out the toilets for him, so that he could resume his job when well. He is thought of with great affection by Orthodox Christians in Greece for his compassion and meekness.

✳ NOVEMBER ✳

NOVEMBER 10

LEO THE GREAT
(c. 390–461) POPE

*L*EO is one of only three Popes to be called "Great." His diplomatic adroitness in both political and ecclesiastical matters earned him this title. He ensured that the twofold nature of Christ became the official doctrine of the Church.

NOVEMBER 11

MARTIN OF TOURS
(c. 316–397) MONK AND BISHOP

*O*VER 4,000 churches in France are dedicated to Martin, who was once the most popular saint in the West. For 10 years he lived as a monk at Ligugé before being acclaimed, against his will, Bishop of Tours.

ST. MARTIN

NOVEMBER 12

JOSAPHAT OF POLOTSK
(c. 1580–1623) BISHOP AND MARTYR

*B*ORN at Vladimir, Josaphat became Bishop of Polotsk in Belarus in 1617. This Orthodox diocese had come into communion with the see of Rome, and Josaphat energetically supported this union, until he was murdered by a crowd of people shouting, "Kill the papist!"

NOVEMBER 13

FRANCES XAVIER CABRINI
(1850–1917) FOUNDRESS

*F*RANCES was the foundress of the Missionary Sisters of the Sacred Heart and worked among orphans, children, and the sick. At the suggestion of Pope Leo XIII she worked in New York and Chicago, strengthening the faith of Italian immigrants there. Frances became the first citizen of the United States to be canonized – by Pope Pius XII in 1946.

NOVEMBER

LAURENCE O'TOOLE
(1128–1180) ARCHBISHOP

WHEN he was 12, Laurence became an Augustinian canon at Glendalough in Ireland, where he was made abbot at the age of 25. When he was 33 he was consecrated Archbishop of Dublin. He was noted for the reforms he carried out within his diocese.

ALBERT THE GREAT
(c. 1206–1280) TEACHER

ALBERT'S claim to fame is that he taught Thomas Aquinas at Paris and Cologne. He was probably the greatest intellectual of the Middle Ages and was called "the Universal Doctor" by his contemporaries. He was a pioneer of the Scholastic approach to theology, which applied Aristotle's way of thinking to revealed truth.

GERTRUDE OF HELFTA
(c. 1256–c. 1302) MYSTIC

GERTRUDE was a German Benedictine nun born at Thüringen and has become one of Germany's most famous Christian mystics. She spent her life studying the Bible and the writings of the Church Fathers and received many visions about God being a pure flame of love, which enlightened both her heart and the world around her. She wrote about this in her book *The Herald of Divine Love*.

ELIZABETH OF HUNGARY
(1207–1231) QUEEN

ELIZABETH married Louis IV of Thuringia when she was 14 and enjoyed family life for six years until Louis died. She had already founded a hospital at the foot of her castle and now she devoted her life to caring for the sick and to the relief of the poor, founding a hospice at Marburg for the elderly.

NOVEMBER

ODO of CLUNY
(879–942) ABBOT

*O*DO, as the second Abbot of Cluny, was responsible for building up the reputation and influence of Cluny throughout France and Italy, where the principles of the Cluniac observance were introduced into leading monasteries. Odo emphasized three things: the value of silence, abstinence, and the common life.

NERSES
(DIED C. 373) BISHOP

*N*ERSES I ("the Great"), or Narses, became the chief bishop in the Armenian Church. He founded hospitals, supported monasticism, and implemented the reforms he had learned from St. Basil at Caeby by summoning the first national synod at Ashtishat, in 365.

EDMUND of EAST ANGLIA
(841–870) KING AND MARTYR

*K*ING of the East Angles and of Suffolk, Edmund was captured by the invading Danes, tortured and beheaded. He died invoking the name of Jesus. In art he is depicted as a robed king, pierced by arrows.

PRESENTATION of MARY at the TEMPLE
(1ST CENTURY)

*T*HIS feast is now also called the Presentation of the Lord. St. Luke records this event in the following words: "When the time of their purification according to the Law of Moses had been completed, Joseph and Mary took him [Jesus] to Jerusalem to present him to the Lord."

LUKE 2:22

NOVEMBER

CECILIA
(2ND–3RD CENTURY) MARTYR

As early as the fourth century Cecilia was one of the most celebrated martyred Roman maidens. For burying the bodies of Christian martyrs she was herself killed. She is patron saint of music, since at her own wedding she was supposed not to have heard any of the music-making but sat on her own, singing to God in her heart.

COLMAN of CLOYNE
(530–606) BISHOP

Born in Munster in Ireland, Colman became the royal bard at Cashel. He was not baptized until he was 50 years old, when he took the name Colman. He is said to have been Columba's teacher while he was Bishop of Cloyne in County Cork.

CLEMENT of ROME
(DIED C. 100) BISHOP AND MARTYR

Clement is remembered for two things. First, his *Epistle to the Corinthians* remains an outstandingly important document from the first century; second, he was martyred in Rome. His well-known prayer, "O God, make us children of quietness, and heirs of peace," reflects his own outlook on life.

CATHERINE of ALEXANDRIA
(DIED C. 310) MARTYR

Tradition asserts that Catherine confronted Emperor Maxentius for his persecution of the Christians. Fifty pagan philosophers listening to this argument were converted to Christianity. Maxentius then had them burned to death. Catherine was condemned to be put to death by a spiked wheel, which miraculously broke. She was then beheaded.

✳ NOVEMBER ✳

JOHN BERCHMANS
(1599–1621) JESUIT

OHN Berchmans, from Diest, Brabant, joined the Jesuit college at Malines in 1615. He died in Rome in 1621, was canonized in 1888, and is patron of altar boys.

MAXIMUS OF RIEZ
(DIED C. 460) BISHOP

MAXIMUS joined the monks at Lérins in France and became their abbot in 426. Later, Maximus became Bishop of Riez.

STEPHEN THE YOUNGER
(DIED 764) MARTYR

TEPHEN the Younger, born at Constantinople, became abbot of Mount St Auxentius. He opposed Emperor Constantine Copronymus' fanatical destruction of Christian images. For this, Stephen, along with 300 monks was killed.

SATURNINUS
(DIED C. 309) MARTYR

UNDER Emperor Maximian's persecution of the Christians in Rome, Saturninus, who came from Carthage, was arrested with Sisinius the deacon. They were sentenced to a life of hard labor, but were then tortured and roasted before being beheaded.

ANDREW
(1ST CENTURY) APOSTLE

NDREW, one of Jesus' 12 apostles, ran a fishing partnership with his brother Peter, and with James and John. Andrew brought his brother to meet Jesus. He also brought a boy to Jesus who had two small fish and five barley loaves, which Jesus used to feed 5,000 people.

DECEMBER

T JOHN OF THE CROSS
experienced great trials and tribulations during his own life. He was kidnapped twice by the Calced Carmelites whom he (with St. Teresa of Avila) wanted to reform. During his second imprisonment he wrote The Dark Night of the Soul, in which he describes healthy spiritual dryness as a condition that enables the soul to experience God's refining fire.

> *"My soul thirsts for you" (Psalm 63:1).*
> *It is a wonderful thing that David says here.*
> *He tells us that his preparation for the knowledge of the glory of God did not lie in any of the spiritual delights and pleasures which he had experienced.*
> *Rather, his knowledge of the glory of God is a result of his times of dryness when he was divorced from his physical nature.*

THE DARK NIGHT OF THE SOUL

✳ DECEMBER ✳

ELOI
(c. 590–c. 660) FOUNDER

ELOI, or Eligius, born in Gaul, became master of the mint for King Clotaire I of France. His craftsmanship and friendship with the king made him very wealthy. He gave much of his money to the poor, built a number of churches, ransomed slaves, and founded a convent in Paris and a monastery in Solignac.

BIBIANA
(4TH CENTURY) MARTYR

BIBIANA, also known as Viviana according to one tradition, was the daughter of Flavian, the prefect of Rome. Flavian was exiled from Rome on account of his Christian faith. Bibiana's mother, Dafrosa, was beheaded. Bibiana and her sister Demetria had all their possessions taken from them. Later they were arrested and scourged to death.

FRANCIS XAVIER
(1506–1552) MISSIONARY

IGNATIUS Loyola sent his friend and follower Francis Xavier to the Orient as a missionary. He became the most famous Jesuit missionary of all time, working so hard that he had only a few hours' sleep each night. He was known as "the Apostle of the Indies" and "the apostle of Japan." His mass conversions became legendary – he baptized 10,000 people in one month and was credited with 700,000 conversions.

JOHN OF DAMASCUS
(c. 675–c. 749) DOCTOR OF THE CHURCH

JOHN, born in Damascus, is known as the last of the Eastern fathers and is noted for his theological writings and his hymns. His book *Fount of Knowledge* is a digest of the Christian teaching of the Greek fathers. His most famous hymn is "Come, ye faithful, raise the anthem."

✳ DECEMBER ✳

CRISPINA
(C. 304) MARTYR

*C*RISPINA was a wealthy mother who lived in Thagara, Numidia, in Africa, during Emperor Diocletian's persecution of the Christians. When asked why she refused to offer sacrifices to the gods, she replied, *"I do observe an edict: that of my Lord Jesus Christ."* After suffering the most shameful indignities she was beheaded.

NICHOLAS OF MYRA
(DIED C. 350) BISHOP

*L*ITTLE is known for certain about this saintly bishop, who may have been martyred. He could have been transmuted into Father Christmas because he was supposed to have saved three girls from prostitution by throwing three bags of money into their rooms for their dowries so that they could marry. These bags are now represented by the pawnbroker's three balls. St. Nicholas is the patron saint of moneylenders.

AMBROSE
(339–397) BISHOP AND THEOLOGIAN

*W*HEN the Bishop of Milan died, Ambrose, who was then governor of Milan, went to the cathedral to oversee an orderly election. He was acclaimed the new bishop, even though he had yet to be ordained. He was known as the "hammer of Arianism" because of his opposition to that heresy and is one of the four traditional Doctors of the Latin Church.

THE FAMILY TREE OF THE BLESSED VIRGIN MARY

*F*ROM the words of the angel Gabriel recorded in Luke's gospel it is possible to infer that the Virgin Mary was a descendant of David. "The Lord God will give him the throne of his Father David, and he will reign over the house of Jacob for ever. His kingdom will never end."

LUKE 1:32–33

✳ DECEMBER ✳

HIPPARCHUS
AND PHILOTHEUS
(DIED C. 297) MARTYRS

EMPEROR Maximus noticed that his magistrates Hipparchus and Philotheus were not present when sacrifices were made to the pagan gods. Maximus then discovered that they had not made such sacrifices for three years. They were tortured and imprisoned for two months, along with their Christian converts, and crucified at Samosata, and so are known as the Martyrs of Samosata.

MILTIADES
(DIED 314) POPE

MILTIADES, from Africa, became Pope on July 2, 311. While he was Pope he saw the end of the persecution of Christians after Constantine became emperor. The heretic Donatus was condemned at the synod that Miltiades held in 313.

DAMASUS I
(C. 304–384) POPE

DAMASUS, one of the leading biblical scholars of his day, wrote out the canon of the Bible, indicating which books were authentic; his list was approved by a council in Rome in 374. We have Damasus to thank for Jerome's Bible commentaries, as Damasus became Jerome's patron.

JANE FRANCES
DE CHANTAL
(1572–1641) FOUNDRESS

IN 1610 Francis de Sales helped Jane to found the Congregation of the Visitation on the shores of Lake Annecy for girls and widows who wanted to follow the religious life, but not the ascetic life. Jane went on to found 66 convents all over France during her lifetime. Francis de Sales described her as "the perfect woman."

✴ DECEMBER ✴

LUCY OF SYRACUSE
(DIED 304) MARTYR

THIS Sicilian Christian fell foul of Emperor Diocletian's persecution for refusing to marry and so became one of the best-known "virgin-martyrs" in the West. In art she is depicted with a gash in her neck because she is supposed to have been stabbed through the throat, after a failed attempt to burn her to death.

JOHN OF AVILA
(1499–1569) PREACHER

BORN at Almodovar del Campo, New Castile in Spain, John was nearly sent as a missionary to Mexico, but instead spent 40 years evangelizing Andalusia and is now known as "the Apostle of Andalusia." He drew great crowds to hear him preach, wrote numerous ascetical books, and gave much spiritual counsel to many people, including St. Teresa.

NINO
(DIED C. 320) VIRGIN

NINO, born in Colastri in Cappadocia, was taken as a slave girl to Georgia, where she became instrumental in spreading the Christian faith through her devout life and by healing people in Christ's name, through her prayers. She is now known as "the apostle of Georgia."

ADELAIDE
(931–999) WIDOW

ADELAIDE, a princess from Upper Burgundy, founded and restored monasteries in her efforts to convert the Slavs. She died in the monastery at Selta, near Cologne, which she had founded.

RESURRECTION OF LAZARUS

➢ *118* ➢

DECEMBER ✶

DECEMBER 17

LAZARUS
(1ST CENTURY) FRIEND OF JESUS

*A*ll we know of Lazarus is recorded in John's Gospel (John 11–12). He was the brother of Mary and Martha and was raised from the dead by Jesus, four days after he had died. This was the occasion when Jesus said, "I am the resurrection and the life. He who believes in me will live, even though he dies" (John 11:25). These words often introduce funeral services.

DECEMBER 18

GATIAN
(DIED C. 301) BISHOP

GATIAN, along with five other bishops, went with St. Dionysius from Rome to Gaul, where he spent 50 years preaching, especially around the area of Tours. Gatian is thought of as the first Bishop of Tours.

DECEMBER 19

NEMESIUS
(DIED 250) MARTYR

UNDER Emperor Decius' persecution of the Christians, the Egyptian Nemesius was arrested in Alexandria, scourged and then burned to death.

ABRAHAM AND ISAAC

DECEMBER 20

ABRAHAM, ISAAC, AND JACOB
(OLD TESTAMENT)

ABRAHAM, Isaac (the son whom God promised Abraham and Sarah) and Isaac's son, Jacob, are known as the patriarchs of the Old Testament. The writers of the Bible often refer to "the God of Abraham, the God of Isaac, the God of Jacob" to stimulate faith in God.

✳ DECEMBER ✳

PETER CANISIUS
(1521–1597) DOCTOR OF THE CHURCH

PETER Canisius was born in The Netherlands and joined the Jesuit order in 1543. He became such an acclaimed preacher that he was known as "the Second Apostle of Germany," after St. Boniface. In 1925 he was canonized and declared a Doctor of the Church.

CHAERMON
(DIED 250) BISHOP

AS an elderly man, Chaermon was forced to flee from Nilopolis, in Egypt, where he was bishop, during Emperor Decius' persecution of the Christians. No one ever saw him again.

JOHN CANTIUS
(1390–1473) TEACHER

JOHN Cantius, held the chair of theology in Cracow. He became famous for his preaching and his care for the poor. He was declared patron of Poland and Lithuania by Pope Clement XII in 1737.

GREGORY OF SPOLETO
(DIED C. 304) MARTYR

DURING Emperor Maximian's persecution of the Christians, Gregory, a priest at Spoleto in Italy, refused to sacrifice to the gods. Flaccus then beheaded him for this.

CHRISTMAS – BIRTH OF JESUS

THE incarnation of the Son of God is recorded by St Luke with great simplicity:

"While they were there [in Bethlehem], the time came for the baby to be born, and she [Mary] gave birth to her firstborn, a son. She wrapped him in swaddling cloths and placed him in a manger, because there was no room for them in the inn".

LUKE 2:6–7

DECEMBER ✷

STEPHEN

(*DIED C. A.D 35*) MARTYR

*L*UKE records the death of Stephen, the first Christian martyr, in Acts 6-7. Even his accusers "saw that his face was like the face of an angel." He died confessing his faith in Christ and asking for his murderers to be forgiven.

JOHN THE APOSTLE

John, known as "the apostle of love," is the traditional author of John's Gospel, three New Testament letters, and the book of Revelation. In his first letter John speaks about Jesus the Savior with these words: "We have seen and testify that the Father has sent his Son to be the Saviour of the world."

1 JOHN 4:14

THE HOLY INNOCENTS

(*C. AD 5*)

THIS day used to be called Childermas since it commemorates King Herod's slaughter of all male babies up to the age of two, who were killed to ensure that Christ never threatened Herod's position by becoming king (Matthew 2). The Eastern Church calls this day the festival of the "fourteen thousand holy children."

DECEMBER

THOMAS à BECKET
(1118–1180) ARCHBISHOP AND MARTYR

*A*s Archbishop of Canterbury, Becket opposed his former friend, King Henry II, when he interfered in Church matters. Becket was exiled, but then returned. In reply to Henry's rhetorical question, "Will no one rid me of this turbulent priest?", four of his knights killed Becket before his own high altar. Henry did public penance, and Canterbury quickly became one of the most popular places for pilgrims to visit.

ANYSIA
(DIED C. 304) MARTYR

*A*NYSIA was a Christian who lived in Thessalonica where she used her wealth to relieve the poor. A soldier killed her with his sword when she was on her way to a Christian meeting and refused to offer sacrifices to the pagan gods.

SYLVESTER I
(DIED 335) POPE

*W*HILE Sylvester was Pope, he fought successfully against the heresies of Donatism and Arianism and built many churches, the most famous of which were the basilicas of St. Peter and St. John Lateran.

The Saints as Patrons
of Countries and Places

HUNGARY
GERARD; STEPHEN

IRELAND
BRIGID; COLUMBA;
PATRICK

ITALY
CATHERINE OF SIENA;
FRANCIS OF ASSISI

JAPAN
FRANCIS XAVIER

LITHUANIA
JOHN CANTIUS

NORWAY
OLAF

PARIS
GENEVIÈVE

PERU
JOSEPH

POLAND
JOHN CANTIUS; CASIMIR;
HYACINTH

RUSSIA
ANDREW; NICHOLAS OF
MYRA

SCOTLAND
ANDREW; COLUMBA;
MARGARET OF SCOTLAND

SOUTH AMERICA
ROSE OF LIMA

SPAIN
JOHN OF AVILA; TERESA
OF AVILA

SWEDEN
BRIDGET

UNITED STATES
THE IMMACULATE
CONCEPTION OF THE VIRGIN
MARY

WALES
DAVID

WEST INDIES
GERTRUDE

INDEX

CREDITS

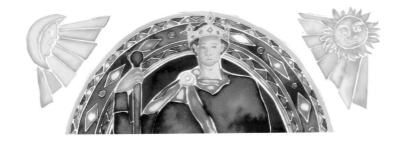